A Mouth Is Always Muzzled

Also by Natalie Hopkinson

Go-Go Live: The Musical Life and Death of a Chocolate City

Deconstructing Tyrone: A New Look at Black Masculinity in the Hip-Hop Generation (with Natalie Y. Moore)

A MOUTH IS ALWAYS MUZZLED

Six Dissidents, Five Continents, and the Art of Resistance

Natalie Hopkinson

THE NEW PRESS

25 YEARS

NEW YORK
LONDON

Requests for permission to reproduce selections from this book should be mailed to: Permissions Department, The New Press, 120 Wall Street, 31st floor, New York, NY 10005.

Poems on pages 47 and 141 © Ruel Johnson, *Collected Poems: 2002–2013* by Ruel Johnson, published by Janus Books, Georgetown, Guyana, 2013. Used with permission.

Published in the United States by The New Press, New York, 2018
Distributed by Two Rivers Distribution

LIBRARY OF CONGRESS CATALOGING-IN-PUBLICATION DATA

Names: Hopkinson, Natalie, author.
Title: A mouth is always muzzled : six dissidents, five continents, and the
 art of resistance / Natalie Hopkinson.
Description: New York : The New Press, 2018. | Includes bibliographical
 references and index.
Identifiers: LCCN 2017022819 (print) | LCCN 2017023829 (ebook) | ISBN
 9781620971253 (e-book) | ISBN 9781620971246 (hc : alk. paper)
Subjects: LCSH: Postcolonialism and the arts. | Arts--Political aspects. |
 Race in art. | Postcolonialism and the arts--Guyana. | Arts--Political
 aspects--Guyana. | Guyana--Social conditions--1966-
Classification: LCC NX180.P67 (ebook) | LCC NX180.P67 H67 2018 (print) | DDC
 700.9/045--dc23
LC record available at https://lccn.loc.gov/2017022819

The New Press publishes books that promote and enrich public discussion and understanding of the issues vital to our democracy and to a more equitable world. These books are made possible by the enthusiasm of our readers; the support of a committed group of donors, large and small; the collaboration of our many partners in the independent media and the not-for-profit sector; booksellers, who often hand-sell New Press books; librarians; and above all by our authors.

www.thenewpress.com

Book design and composition by Bookbright Media
This book was set in Minion and Cholla Sans

Printed in the United States of America

10 9 8 7 6 5 4 3 2 1

To my grandmothers, Christina Elizabeth Baird and Gertrude Elizabeth Henry Hopkinson. And in memory of my cousin Gary George, who always made sure I felt at home in Guyana.

Contents

A Mouth Is Always Muzzled

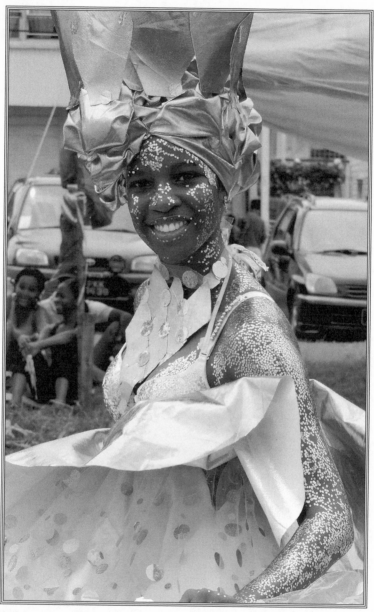

When it was established in the 1970s, the Mashramani celebration represented a revolutionary new aesthetic.

1

Your Eyes Pass Me

> I want to play a new melody. I want to find a new colour. And
> I want to proclaim like Schopenhaeur. "The world is my Idea."
> —*Bernadette Persaud*[1]

It's like any other carnival. Mashramani, or "Mash," is a giant street
party. These libidinous, color-soaked pageants happen all around
the world. In Guyana's version, a rainbow blur of people, costumes,
floats, sound systems, steel pan, chutney, soca and calypso musicians
compete for prizes, attention, respect. Long after the sober hours
when I began walking Georgetown's parade route in 2015, it would
climax into a boozy orgy of wining down and back-balling deep into
the night.

Guyana bills itself as the "Land of Six Peoples," and Mash-
ramani puts them all on display. It is not a scene you expect to
find on the northern edge of South America: Think Accra meets
Mumbai—through the lens of the indigenous Amerindian. Most of

"Your eyes pass me" is a common Guyanese expression uttered when one feels insulted by
someone who does not know their place. I heard this phrase, as a statement or a question,
from my parents many times during my childhood. If my siblings or I did something they
thought disrespectful: "Y'eyes pass me?" It also can be phrased as a statement of outrage:
"You. Eyes. Paaaasss ME!"

Guyana's nearly eight hundred thousand people are squeezed onto a tiny coastal strip carved from the dense rainforest adjacent to Venezuela, Suriname, and Brazil. The language is English by way of Great Britain. Much like its cuisine, its culture is filled with loud and pungent flavors that don't always mix well: roti and curry from India; metemgee stew from Africa; garlic pork from Portugal; pepper pot from the Amerindians; chow mein from China. Mash parade and festival is like "cook-up rice," a jambalaya that is uniquely Guyanese.

The festival is a great time. But as I pass cheery floats on streets bearing English and Dutch names lined with aged but stately wooden homes, I feel a sense of dread. A national election is coming up, and everyone knows that in Guyana, elections mostly mean trouble.

What most people here don't know yet is that the stakes for this election are even higher than usual. ExxonMobil discovered a $200 billion (USD) cache of oil and gas off Guyana's Essequibo Coast.[2] This find could be more lucrative than the American company's interests in Russia. Control of Guyana's government could yield a higher bounty than at any point in the country's history. It would turn out to be a murderous election campaign.

As in many parts of the world, power shifts and violence have always gone hand in hand here. Guyana was once the British Empire's only foothold in South America. The Brits wrestled it away from the Dutch, French, and Spanish in the European scramble for control of the seas and world markets. Known then as British Guiana ("land of many waters"), its lush rainforest climate once produced some of the most profitable sugarcane crops in the world. Its strategic access to the Atlantic and colonial investments made it a shiny bauble on the map of Empire.

Guyana is one of several West Indian nations currently seeking reparations from Europe for Native American genocide, slavery, and the enduring effect of the sugar trade. Calculating Great Britain's debt to black workers may be more straightforward than in the United States. Soon after the abolition of slavery in 1833, British Parliament paid out £20 million to compensate slave owners all across the Empire—but never the actual slaves. The infusion of cash to slaveholders vested an outdated, inefficient plantation system, which served as a stimulus package that helped to modernize Great Britain, according to the Barbadian historian Sir Hilary Beckles. Until the 2009 banking crisis, it was the biggest bailout in British history.[3]

At the time of abolition, British Guiana was among the newest, most fertile and profitable of the British colonies. British Guiana slave owners were well represented in Parliament and every other institutional pillar of English society from the church to the banking industry. These powerful investors demanded terms favorable to them. The ransom to free each of my Guianese ancestors was £51, whereas my husband's purportedly less profitable Jamaican ancestors each fetched £21 from Parliament. British Guiana planters also demanded that the government help them ship hundreds of thousands of contract workers from India to replace the enslaved Africans on plantations. They also brought in smaller numbers of Portuguese and Chinese contract workers. But more Indian workers came to British Guiana than to any other place in the Empire.

How slavery ended—by gun in the United States in the 1860s and by bailout in the United Kingdom in the 1830s—continues to shape these cultures. In the United States it intensified antipathy toward black people, who are living reminders of what some white

people believe they have lost. In the U.K., the bailout helped them forget how much of their own material comforts were pillaged from other cultures around the world. These unresolved conflicts came back to a roaring head in the twin piques of Brexit and the election of Donald J. Trump. The white nationalist turn in global politics shows lingering bitterness toward the black and brown workers who built a modern Europe and United States. Trump's choice for secretary of state, Rex Tillerson, Exxon's CEO at the time of the 2015 oil discovery off the coast of Guyana, will be setting policies that will determine whether this pattern of exploitation repeats itself.[4]

Even before anyone cashes in on the latest discovery, the historic debt to workers in places like Guyana continues to accumulate interest. When the British exited Guyana in 1966, they left behind a rum culture, a legacy of alcoholism and diabetes, and a grudge match between brown and black sugar workers. Fifty years after independence, Guyana has virtually fallen off the global map. It is now the second poorest country in the Western Hemisphere, behind Haiti.[5] Its currency trades at $200 to $1 USD. Thousands leave the country every year. More Guyanese-born people live outside the country than inside. Guyana has the world's highest suicide rate, nearly double that of anywhere else in the world.[6]

Amid economic and political turmoil, national rituals such as Mashramani are bravura displays of resilience, vitality, and cultural memory. Times of social upheaval force the meaning and stakes of art in the public sphere to rise to the surface.

Mashramani was named for an Arawak word said to mean "celebration after hard work" and created to fete the newly emancipated Guyanese, freed of more than a century of British oppression. Today, the tyranny appears to come from closer to home.

Two ethnic groups have dominated politics in the half century since Guyana's independence: Indians, who are the largest ethnic group, comprising just over 40 percent, and Africans, who comprise 30 percent of the population. There are also smaller communities descended from Portuguese and Chinese indentured workers and those of mixed race, and nearly 12 percent of the population is indigenous Amerindian.

Guyana's upcoming 2015 national elections were the subtext to every word, gesture, and step people made along the Mashramani parade route. The ruling Indian-dominated People's Progressive Party (PPP) alarmed the international human rights community with corruption and graft, alliances with drug traffickers, police torture, sexual abuse scandals, and assaults on press freedoms. Even former U.S. president Jimmy Carter, who helped the PPP win power in Guyana's first free and fair democratic elections in 1992, is concerned. In a few weeks, the nonagenarian Carter would come to Guyana with a delegation of observers to keep the peace.

Culture is where the future is negotiated. What I see along the 2015 Mashramani parade route is a performance of history, power, and resistance.

"You like the warriors?" Guyana's minister of health, a Moscow-trained surgeon, interrupts me as I snap photos of the Wellness Warriors float his government agency sponsored.[7] A thirty-foot jaguar floats down Church Street, leading a procession of young revelers wearing spotted jaguar-themed costumes. Girls in short body-hugging jaguar prints shake little jaguar tails. They fight for good health with metallic gold helmets and matching gold armor. The boys have baggier jaguar costumes, and many hoist golden shields embedded with tiny arrangements of plastic fruit.

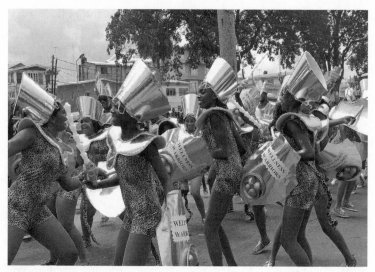

The government's health ministry sponsored this award-winning float, the Wellness Warriors.

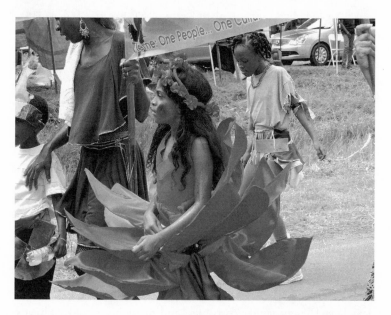

The word "Mashramani" is said to have originated in the Amerindian Arawak language. Participation is compulsory for all Guyanese children.

Fruit is a shield. Get it? Wellness . . . Warriors! I will see this sort of literal, direct messaging via government-sponsored floats all day: The "Heart of the Amazon" float is a ginormous red Valentine's Day–like heart. Models of skyscraper buildings appear on several floats because the government is *building a nation*. The Ministry of Agriculture float includes a larger-than-life-sized cardboard cut-out illustration of a white man spraying insecticide, and all of the costumes are randomly festooned with fake leaves and more plastic fruit. Another float from the Chinese Association of Guyana celebrates "Our Cultural Diversity in the Year of the Sheep" as people wave Chinese and Guyanese flags. A traditional dragon springs to life, reminding onlookers of visiting Chinese workers building an overdue and overbudget Marriott hotel here.[8]

"Yes," I reply to the health minister. I liked the Wellness Warriors well enough.

"Join dem," Dr. Bheri S. Ramsaran commands, leering at me beneath an orange *Guyana* baseball cap, a scruffy goatee at his chin and hefty sideburns.

A crackly PA system pelts out a staccato soca beat from Trinidadian duo JW and Blaze's infectious jump-up hit song:

Palance! Jump up and mash up de place!
Palance! Mashing up de place!
Palance! Jump up and break up de place!

I glance at the young people—mostly African with a sprinkling of Indian youth—doing the "palance" dance: popcorn pops from side to side in diagonal lines. They seem joyful enough. But rumor is, the health ministry and most of the other government ministries paid revelers 8,000 Guyana dollars ($40 USD) each to participate—an election-year bribe.[9] The young jaguars wave plastic guns in

the shape of Nemo, firing plastic bubbles en route to their final destination at the National Park. Mashramani judges will assess them much like a Queen Victoria Jubilee royal court appraising its subjects.[10] The Wellness Warriors will take second place in the small "semi-costume" category.

I politely smile at the health minister but decline to *mash* with the warriors. I try to go back to shooting photos, but Dr. Ramsaran just takes a step closer. "You Guyanese? You look like foreign." He is of Indian descent but pale beige like my dad's side of the family, which has roots in Africa and Europe.

"Yes—my parents," I reply. My DNA claim is solid. Is it that obvious I was born in Canada and live in the United States?

In one month Guyana's president will bow to international outrage and fire the health minister. Ramsaran will cross several lines during a heated exchange with an activist protesting conditions in the maternity ward at the public hospital. The surgeon will tell the Indo-Guyanese activist, Sherlina Nageer, that hospitals were in far better condition than when the African-dominated People's National Congress (PNC) ran the country twenty-three years earlier. When she refuses to back down, he will call her an "idiot," a "piece of shit," and order security to carry her off. The whole exchange will be posted on YouTube, where the minister can be heard saying he should have her stripped and "slap her ass just for fun."

But that is weeks from now. Today is Mashramani day, and the minister is having fun tugging puppet strings at his show. He whips out a pen. "Let me give you my name and my number . . . in case you want to join the warriors," Dr. Ramsaran says. He jots down his personal cell phone number on his government business card.

He presses it into my hand and continues to the next stop on the parade route.

One person I won't see at Mashramani is my friend Vidyaratha Kissoon, an award-winning blogger, teacher, and LGBT activist born in 1970. Like many Guyanese of Indian descent of a certain age, Mash to him is a "black man ting" he can't separate from the cultural oppression of the two-decade rule of Forbes Burnham, the PNC founder who ran the country after independence. "Mashramani is vulgar and nasty. It's a big joke. It's one of these artificial things created by Burnham. I couldn't bother," he says. He was not the only one who bemoaned the heavy hand of the government in the parade. Under both African and Indian rule, the government co-opted the calypsonian tradition of political critique by requiring competitors to sing sonnets of praise to government leaders.[11] More recently, the Indian-dominated PPP demanded critical calypso hits be yanked from radio broadcasts and required calypsonians to submit their lyrics before being allowed to vie for cash Mashramani prizes.[12]

Kissoon also doesn't approve of what he sees as mimicry of other regional cultures. "They are trying to make it into Carnival. Stupid jumping up about 'we are all one' and all that crap. It is awful. The music is really Jamaican. And my Amerindian friends tell me that 'Mashramani' is not really Arawak."

If any celebration in Guyana unites all cultures, it's Christmas, when people of all walks light up Georgetown each December, Kissoon says. This may be true—but it is odd. This is a holiday in which children are compelled to genuflect to a fat white man in a red suit. The Christian religion was particularly oppressive to East Indian migrants, who were barred from church-run schools unless they converted from Hindu or Islam. But I often hear this excessive self-criticism and nostalgia for the unified culture forged under British rule from black and Indian alike. It is part of the cultural residue of white supremacy.

These are the kinds of ethnic grudges raging beneath the surface of every conversation here. Like an arranged marriage that began to rot ages ago, the various races in Guyana know exactly how to swing where it hurts. As the senior citizens who arrived as slaves with the Dutch in the early seventeenth century, Africans love to flaunt their mastery of the cultural tools of the European oppressor. Some consider themselves more British than the British—"Afro-Saxon" in Lloyd Best's phrasing.[13] When Indian indentured workers arrived to replace enslaved workers on sugar plantations after the abolition of slavery in the mid-nineteenth century, they kept their names, religions, cultural traditions, and identity. Some Indo-Guyanese look to their caste-conscious ancestral home in India for matters of high culture and taste and mock these Afro-Saxons as "deracinated" people bereft of their own culture.[14]

Guyana's nearly eighty thousand Amerindians have been in South America the longest, but essentially live in a world apart, concentrated deep in the hinterlands. Although they have the strongest historic claim, they are generally much less strident on notions of Guyanese "authenticity." They tend to leave these arguments to the more recent arrivals bickering among themselves along the Atlantic coast.

Like everything else in Guyana, there are competing explanations for the origins of the word "Mashramani." When I ask young revelers on the street what Mashramani means, many of them recite the same phrase with the dutiful, rote affect of kindergarteners at morning meeting: *"It's a celebration after hard work."* According to the official history, People's National Congress (PNC) Afro-Guyanese leader Forbes Burnham created Mash in 1973 as the national celebration of the moment he declared the country a "cooperative republic." Burnham chose February 23 because it was the day of the historic 1763 slave rebellion against the then-Dutch rulers led

by an Akan slave named Cuffy. He led five thousand enslaved workers to take command of the plantations and ruled as governor of Berbice for nearly a year. As Burnham explained in an address to "comrades," delivered in crisp Afro-Saxon elocution refined during his law training in London, Mashramani is a celebration of freedom from colonial chains as well as the collective work of many.

The name Mashramani was inspired by a memory of one organizer's aging relative of an Arawak marriage celebration, an Amerindian pronunciation of the phrase "muster many," according to a government-sponsored program published in 2015.[15] The Wayne State University linguist Walter Edwards was part of the team of advisors. He says the Arawak word they elicited was *"masedeme"* (popularly known as *"matriman"*). "It labels a day when members of the village would help [one] another cut a new farm or build a house etc.," he told me in an e-mail.[16] "At the end of the day the helpers are treated to food and drinks by the host as appreciation for the assistance. It's a celebration of work accomplished and neighborliness."

Some Amerindians have disputed this. The historian and mountaineer Adrian Thompson, who first planted the Guyana flag on Mount Ayanganna in 1973, settled the matter thusly: "I don't know the word and its meaning. I suspect that no one does. Therefore, go ahead and use it."[17]

This may be as close to "authentically" Guyanese as it gets.

In the early 1970s when Mashramani began, Guyana's first leader after independence was walking a tattered tightrope. PNC founder Burnham dodged arrows from all directions. Guyana's Indian demographic majority loathed him for cheating their votes and colluding with Great Britain and the United States to betray and then bully his former ally, a popular Indo-Guyanese, American-trained dentist named Dr. Cheddi Jagan. In 1950, Burnham co-founded

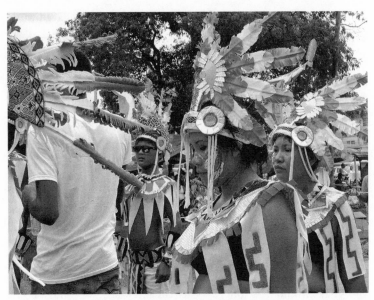

Nearly eighty thousand Amerindians still live in Guyana, the only ethnic group whose numbers are growing.

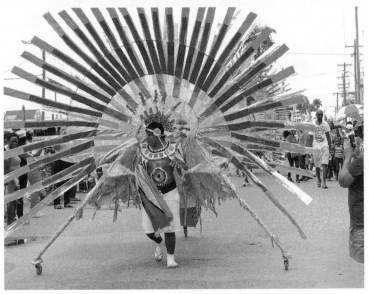

This float was sponsored by the government's Ministry of Amerindian Affairs.

the People's Progressive Party along with Jagan. But during the Cold War panic over the spread of communism, the United States and Great Britain supported Burnham and helped him break away to found a new party, the People's National Congress. With the help of the CIA, the PNC instigated strikes and racial violence against the democratically elected PPP.[18] The conflicts became so intense, a petition to partition the country into African and East Indian sections drew more than five thousand signatures. The proposal was ultimately rejected. Guyana instead became a pluralistic society where races "mix but don't combine," as the Guyanese cultural scholar Vibert C. Cambridge notes.[19]

The British and the Americans looked the other way as Burnham rigged election after election to keep the more overtly communist PPP out of power until his death in 1985. Burnham also had to watch his back for leftist radicals in the Black Power movement spreading across the formerly colonized world. These young scholars (most famously the pan-African historian Walter Rodney) were emboldened by their Caribbean neighbor Fidel Castro, and openly threatened black leaders with strong imperialist ties.[20] Burnham fended off these threats by trading neckties for Cuban collars and presenting himself to the people as the biggest, baddest socialist of them all. In the early 1970s, government coffers were flush with sugar profits, thanks to historically high prices. Burnham spurned his Western backers by declaring that Guyana had become a socialist "co-operative republic," in a nod to the informal co-operative societies created by enslaved Africans in Guyana.[21]

The American reprisal was swift. At the height of the Cold War, the United States, which had pumped $18 million into Guyana in 1968, became even more determined that another Cuban-style revolution would not take root in the Americas. After Burnham's left

turn in 1974, U.S. aid to the new "co-operative republic" plummeted to just $200,000. The British had withdrawn since independence in 1966, and the loss of financial support turned out to be a devastating blow. After the mid-1970s, sugar prices took a nosedive from which they would never recover. Guyana was effectively economically shipwrecked.

Burnham expected sugar to eventually rebound; he stayed the course. He tried to establish his revolutionary bona fides both internally and externally by proclaiming himself the "Comrade Leader," nationalizing most commercial activity including the bauxite and sugar industries. He turned to Russia, Cuba, China, and North Korea for economic development models—and for guidance on matters of culture.

New traditions such as Mashramani were Burnham's attempt to seize an independent Guyana and mold it like a lump of clay into something brand-new. Burnham, whom V.S. Naipaul once pronounced "the finest public speaker I have heard" was a charismatic lover of the arts and the son of a schoolmaster who believed that education and culture were the tools of self-liberation.[22] When he was an attorney in practice under British rule, among his first clients were musicians who complained of police harassment when they were charged with disturbing the peace for playing steel pan music and parading without permission. He also defended Guyanese from archaic colonial laws such as the Obeah Suppression Law of 1851, which targeted *obeah*, the traditional African voodoo-like folk magic, according to the Guyanese cultural scholar Vibert C. Cambridge.[23]

As part of this cultural movement in the 1970s, President Burnham required all state-owned businesses to sponsor a steel band, which he declared Guyana's "indigenous" music. Burnham took

control of all schools formerly run by Catholic and Anglican church-
es that excluded or oppressed Amerindian and Indian children who
refused to convert. He established the pan-Caribbean arts showcase

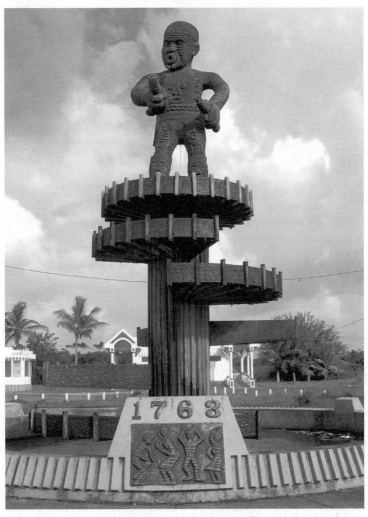

The sculptor Philip Moore created this monument to Cuffy, an Akan enslaved man
who led a 1763 revolt and ruled the Berbice area of Guyana for nearly a year. Photo
by David Stanley Creative Commons license 2014.

After independence, the steel pan was named Guyana's indigenous musical instrument.

Carifesta. Burnham commissioned a monumental wood carving of Cuffy in Georgetown by the visionary sculptor Philip Moore, which some have jokingly speculated was actually an *obeah* symbol that protected the dictator.

Burnham also commissioned a monument to the Indo-Guyanese Enmore Martyrs, killed in a 1948 uprising against sugar lords, but geographically marginal to the national power center in Georgetown. Burnham further infuriated the East Indian community by tapping the remaining escrow cash from government coffers, originally earmarked to pay the travel costs of indentured servants who decided to return to India. Burnham used it to build the National Cultural Centre, a 2,200-seat auditorium and performing arts venue.

Perhaps most contentiously, as part of this cultural self-reliance

movement, in the 1980s, Burnham banned agricultural imports including apples and flour. This ban was an early, and heavy-handed, attempt of the sustainable, go-local movement to support locally produced products such as cassava bread that were made in the Amerindian villages. It was wildly unpopular. It made roti—one of Guyana's signature dishes, a gift from India—illegal.

The Democratic People's Republic of Korea (DPRK) provided inspiration for the ban on imports. Northern Korean Juche is a Marxist-Leninist-inspired philosophy of revolutionary self-reliance. With Cuba taking most of the attention from Moscow, and China showing little interest in Guyana, North Korea became a big brother nation, providing some economic aid and advice on everything from agricultural policy to school discipline. North Korea, an outcast nation, saw a partnership with Guyana as a path to global influence and goodwill. Driven by the counsel of the North Koreans, Guyana added what are known as "Mass Games" to the Mashramani celebrations. These massive performances of coordinated gymnastics involving hundreds of schoolchildren took place in large arenas, usually with propagandistic images in the background. North Korean teachers traveled to Guyana specifically to teach students how to stage these events. The games were designed to show unity, strength, discipline, and order, emphasizing the collective over the individual, according to Moe Taylor.[24]

The central idea of the self-reliance movement was to look inward, to fellow countrymen, for heroes and to express the culture of the "New Guyana Man." All of the excesses of capitalism and white supremacy, and vestiges of both, would be erased. In its place an equitable, unique, and inclusive culture would rise. *Cultural Policy in Guyana*, a 1977 document written for UNESCO by the Guyanese poet A.J. Seymour, explains the Burnham administration's

In the early 1980s, the Democratic Republic of North Korea advised Guyana on how to create massive murals of their Supreme Leader during Mashramani. Photo by Moe Taylor.

intellectual blueprint for cultural revolution. The hope was that "a national soul" would be born, "able to inspire the highest and deepest types of motivation." Seymour adds: "For the artists of Guyana, the revelation of a national identity is the most revolutionary possibility that exists. The Guyana man has to re-create himself in his own image as an indispensable basis on which to realize the image of a national identity."[25]

There were a few problems with the plan. In lifting up the culture of the "Little Man," women were at best implied. And, for the most part, the cultural policy document left out the majority of Guyana's population who were descendants of East Indians.

For the celebrated painter Bernadette Persaud, Mashramani brings back painful memories of the 1970s, when she was one of the few artists of Indian descent, painting, teaching English, and raising small children. "All of it was militaristic. 'Produce or Perish.' The latest slogan: 'One People. One Nation. One Culture.' This

was a very significant chapter in our lives. And it explains a lot, why culturally, why we are so suffocated. And why we have art, and we have an 'official art.' I realize that this is the root of my antagonism," Persaud says.

"You would not understand the chills I went through when I sat in the room at the art school. I would see other artists in uniform, hustling for these books." Persaud clashed with her superiors at the art school over being ordered to weave in elements from a Hindu festival. "That was the second time I had to walk away from a job," she said.

National preparations for Mashramani grew intense. Many parents wrote letters complaining that their children were losing months of regular instruction in order to practice gymnastics routines, make costumes, and build floats. The children were expected to create monumental images of Forbes Burnham—the Constitution of 1980 declared him "Supreme Leader" for life. The portraits were done in panels. "One student might have his ears," Persaud recalls. "You know, in the Korean tradition where you have [images of] the leader. I have no classes and my children are holding up Mr. Burnham ears, a part of his nose."

Along with the ban on imports, the Mass Games were quietly abandoned after Burnham's death in 1985. My maternal grandmother, Christina Baird, is of mixed heritage and a onetime Burnham supporter who eventually soured on him. "De wooorst president!" she says with a laugh. The Guyanese were so worked up over the ban on wheat that she recalls hearing about people throwing loaves of bread at the Supreme Leader's coffin.[26]

Mashramani, however, survived and continued to be supported under Indian rule.

The painter Persaud's feelings about Mashramani have not changed even though the PNC party has been out of power for twenty-three

years. "It's still compulsory. Up to now it hasn't changed," she says. The Indian-dominated People's Progressive Party has operated under a strong authoritarian influence from Moscow where many of the party leaders were trained. Persaud says that basic authoritarian structure remains in many Guyanese institutions, including the museum, education, and culture ministries. She says the PPP is a political party bent on appeasement. "Appeasement and trying to get more supporters. So they are appeasing Amerindians. They are appeasing black people. So they take for granted that the Indian is their property."

"We can have all kinds of hybridities and so on, in our situation," Persaud continues. "But in trying to import that ideology here, they have to deal with the Guyanese indiscipline."

Given that this terrain is so culturally bloodied, it makes W.E.B Du Bois's notion of a mere *double* consciousness sound mild by comparison. It is a wonder that Mashramani has survived at all. Of course it's artificial, or man-made. But the same must be said for Guyana, period. There is nothing organic about shipping hundreds of thousands of people from Africa and India to grow sugar. What else would Mash, or any other human celebration for that matter, be?

When I witness Mashramani 2015 a month before the national elections, I see a large number of Africans participating, but the crowds of young people are of many races. Most of the revelers— like the voters who will go to the polls in a few weeks—are not old enough to remember the PNC days, the ban on bread, or what life was like under the Supreme Leader. An estimated 60 percent of Guyana's voters are under the age of thirty-five. "Mashramani is not really segregated you know," Muniram Deonaraine, a nineteen-year-old University of Guyana economics student of East Indian descent says. "It's everyone coming together under one purpose to celebrate."

Other young East Indians say "Mash times" is something they look forward to all year. A lack of art instruction makes the competitions a creative reprieve, says Bibi Nariefa Abrahim, a twenty-four-year-old researcher and recent graduate of the University of Guyana. "That way it [isn't] just books and books and books."

Cambridge, the cultural scholar and president of the Guyana Cultural Association of New York, believes Mash has evolved into something that *is* organic. "There is still the state presence—each ministry has a band," he says. "But when you look at a Mashramani band today, you can see all ethnicities wining down. I see a variety of color palettes. It is definitely a generational thing. It is an aesthetic thing. And it's still a political thing."

Ruel Johnson, a thirty-six-year-old poet and essayist, two-time winner of the Guyana Prize for Literature, and founder of the Janus Cultural Policy Initiative, believes this organic cultural change ultimately will translate into political change. If the majority of Indian voters continues to vote only for the Indian party, and simply bribe or pick off a few votes from the other races, there will never be a change in leadership. "Because of the cultural divisions, there has been a level of impunity that has developed," he says. This idea is what ultimately has held back accountable governance and development in Guyana, Johnson believes. "If you have an ethnic census in every election, then no matter how bad the government, there is no need to change structures. You just keep getting worse."

Johnson believes developing and deploying an effective cultural policy will be key to healing ethnic divisions. So will building on Guyanese traditions such as Mashramani, which now makes room for a tapestry of cultural expressions from chutney to calypso to Mari Mari. "We need to know more about each other. We need to

reflect on our history of trauma. Once that cultural bottleneck is cleared, there is a space, a conversation," Johnson says.

Along the main leg of the parade route on Church Street, handsome wooden houses hint at Guyana's colonial past and are reminiscent of New Orleans' Uptown district. A very wide median is filled with food vendors, overgrown grass, and trash. Families and children sit on the weeds to watch. Some hold up Digicel umbrellas to fend off the powerful equatorial sun stabbing through the clouds.

Maybe I arrived too early in the morning, before the effects of the Demerara rum and Banks beer had kicked in, but at first, the energy of the crowd struck me as very *wha'ya'gon'do*? Georgetown is a mostly Protestant city (with heavy shades of Hindu and Islam). Mash lacks the wanton, cackling energy of Carnival celebrations in more Catholic cities such as Port of Spain, Trinidad; Salvador, Brazil; and New Orleans, Louisiana. Maybe there is too much British

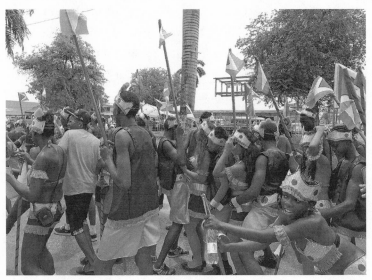

Among the young people celebrating, ethnic groups mix freely.

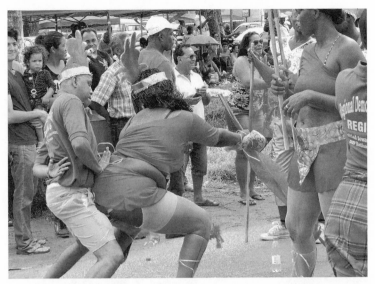

It wouldn't be carnival without some "backballing."

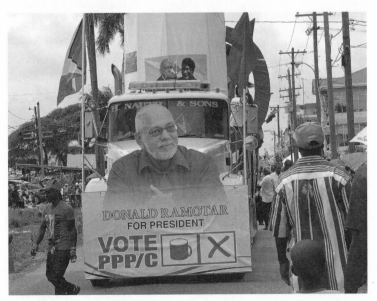

Just weeks before the 2015 national elections that would be observed by former U.S. president Jimmy Carter, the ruling, Indian-dominated People's Progressive Party government used the occasion of Mash celebrations to do some electioneering.

President Ramotar, the People's Progressive Party candidate for reelection, wines down with a constituent on Church Street.

stiff-upper-lip repression, and not enough hardcore Catholic sexual repression in Guyana.[27] Early waves of the parade have the plodding pace of an Anglican dirge. Every now and then, maybe in pity to bored onlookers, a woman will pause to drop her knees to the ground and hump it, or break into the *dutty wine*. Or, a couple will pause to back-ball—grinding their bodies together to the soca beat. An eyebrow or two will rise, and then, in a flash, they trudge on.

Things start to heat up as the day wears on. The PPP candidate up for reelection is President Donald Rabindranauth Ramotar. His face is plastered all over government floats in photographs blown up to a monumental scale that would make North Korea's supreme leader Kim Jong-un proud. There the Indo-Guyanese leader is, coating the front of a semi truck, his salt-and-pepper beard neatly trimmed, hands clasped in front of him against a blue button-down

shirt. There he is again, squared up next to his running mate, near a graphic of a ballot box with a check marked next to "PPP." See President Ramotar in a dark suit, red tie, without spectacles, smiling slightly. I see his blown-up image so many times, I am caught off guard when I see him in the flesh, crossing my path among the spectators in jeans and a red polo shirt. His head is half-covered in a huge cacique—an Amerindian chief's headdress festooned with beads and a rainbow of feathers. His strikingly white teeth flash into a grin as he grips hands with his constituents along the parade route. He glad-hands some, and bends over to whisper something in the ear of a middle-aged woman who works in the government. A tall, stout bodyguard appears to hover slightly.

A round Afro-Guyanese woman in a massive pastel church hat approaches the president near Cummings Street. I can't tell if they exchange any words first, but next thing I know, she is wining and grinding against the president of the Co-operative Republic of Guyana. His Excellency flashes that high-wattage grin, hands raised in the air as he dutifully lunges back at her in a series of quick pelvic thrusts. The delighted crowd laughs and snaps cell phone photos.

A voice crackles over a brittle public address system. The deejay banters with the crowd on the truck and in the street as he introduces the Ministry of Amerindian Affairs float.

> *When me de here on the truck is BARE vibes!*
> *Bare ENERGY!*
> *Watch dem in de band!*
> *Watch dem pon de road!*
> *Ministry of Amerindian Affairs!*
> *"Só beber" whoa!!!*
> *What you say, tall man?*
> *Lardddd!!!!*

Brazilian artist Pepe Moreno's popular ode to a crazy gringa who likes to drink, "Americana Quer Beber," is playing over the speakers.

> *Quer beber.*
> *Beber!*
> *Bebeeeeeer!!!*

Get out the camera. Here comes *the* money shot. It's the shot tourists and professional photographers live for, the one plastered across book covers, magazine spreads, and postcards. This scene is the immediate shorthand for Authentic Culture and the Colored World. A shirtless Amerindian man with white shorts pulls a color-ful metallic wingspan fanned out so wide that it has to roll on wheels on either side of him. Behind him, the rest of the band marches in loincloths fashioned from white and gold polyester and shimmer-ing caciques made of red, yellow, and blue feathers. The colors are bright. The costume is handmade. It is exactly the kind of image typically used to represent exotica in places like Guyana.

At upward of 12 percent of the population, the Amerindians form a critical swing vote. They have been courted heavily by the ruling Indian-dominated PPP, and their closest rival, A Partner-ship for National Unity (APNU), a multiracial coalition led by the African-dominated PNC.

If the Amerindian revelers are excited about the six thousand solar panels the PPP government has just promised to install in villages, they do not convey it.[28] If they are upset about the yellow rope at their sides, literally keeping them in line, they will not say. If they are as enraged as I am over the PPP government's deal to lease their ancestral land to the Chinese for $25 USD per one hundred acres,

and the rapid destruction of precious rainforest trees that take five hundred years to grow, you cannot tell by their faces.[29]

They are not jubilant. They aren't angry. They appear resigned. This too shall pass.

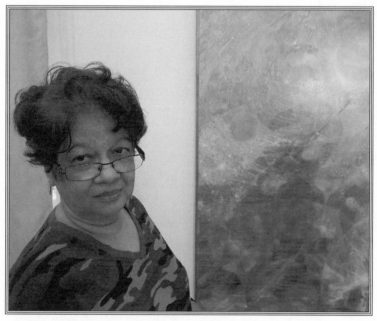

Bernadette Persaud in front of one of her paintings in the permanent collection of the Castellani House, Guyana's fine art gallery.

2

Lady at the Gate

Art changes nothing here.

—Bernadette Persaud, 2000[1]

We are just over a month away from national elections, standing in possibly the only fine art gallery in all of the Co-operative Republic of Guyana. I'm at the National Gallery of Art at Castellani House with one of the country's most celebrated and provocative living artists. Bernadette Persaud is trying to keep a low profile, but it's clear that the exhibit theme, *Spirit of Revolution*, is aggravating the sprightly sixty-eight-year-old. She wears a camouflage V-neck T-shirt, dark slacks, and comfy sandals. Her red-tinted glossy brown hair is styled in a smooth short bob.

Revolution? Her demeanor asks. *Let's go.*

We slip into the third-floor exhibit, and a museum staffer spots her immediately. "This is Ms. Persaud, Ms. Bernadette Persaud," the docent Simone announces. The room is filled by a group of visiting children from Belvedere Primary School, near the Corentyne River. They have taken this rare field trip into the Georgetown capital as part of Mashramani celebrations. Their uniform is starched light

blue shirts, pleated navy skirts, giggles, braids, and royal blue hair ribbons in the British primary school style.

"She had a show here last year in . . . November?" Simone looks to the artist.

"May," Mrs. Persaud corrects. She looks down her nose through glasses in a way she has. "Independence and Arrival Day."

The exhibit, *As New and as Old*,[2] was a career retrospective for Persaud coinciding with Arrival Day, a national holiday commemorating the date in May 1835 when the first indentured workers arrived on ships to British Guiana. Five-year contract workers were the British Empire's solution to the labor crisis that followed when Great Britain's Parliament abolished slavery. Powerful British Guiana planters demanded the biggest payouts for each African enslaved worker who was liberated, more than double the rate paid in the rest of the Caribbean. British Guiana planters then demanded the largest number of Indian contract workers to replace them in all of the Empire. The Arrival precipitated this most unexpected outpost for the Indian diaspora, here on the northern edge of South America. Indians became Guyana's largest ethnic group, with Africans a close second.

Mrs. Persaud's great-grandparents were among the more than 230,000 people shipped to Guyana from India to work the sugar plantations until the practice was abolished in 1917. They fled their native Bihar, India, with an infant—Mrs. Persaud's grandmother— whom they feared might become a casualty to the practice of infanticide of girls. She believes this makes her ancestors brave and heroic people. But she is not about to celebrate the British planters and colonial authorities responsible for the trip. "It's like [Chinua] Achebe's *Things Fall Apart*," she tells me. "Change would have come in any

case. So it wasn't the white man. I mean, he made it more *dramatic*. He came and imposed his *religion . . .*"

Mrs. Persaud used the occasion of the 2014 exhibit to expose the appalling state of Guyana's national art collection, housed in a handsome three-story wooden structure built around 1880.[3] Mrs. Persaud was furious to discover her paintings and countless other priceless artifacts in the museum waterlogged, termite ravaged, and covered in insect dung. Her forceful complaints embarrassed the ruling and Indian-dominated People's Progressive Party and caused a quarrel in the press that ended with the museum's longtime curator locked out. Less than a month before our visit, the curator resigned.

She figures the fuss still makes her "Persona Non Grata, the Peoples' Republic of Guyana," as Mrs. Persaud jollily tells the children. The museum docent doesn't dispute it. "Yes," Simone agrees.

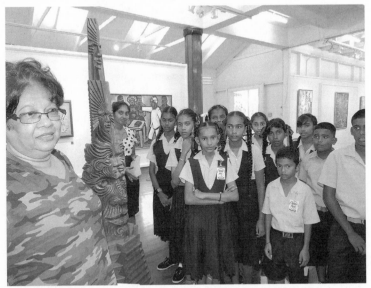

Children visiting the Castellani House get an impromptu lesson about art and politics.

"These people know me well," Mrs. Persaud says with a chuckle.

Simone scans a catalog to find an example of Mrs. Persaud's acrylic paintings to show the children. "Tell them I paint soldiers—with guns." Persaud says. The artist likes to be precise. "That must be an AK," she tells the children.[4]

Mrs. Persaud's now-iconic Gentlemen in the Garden series critiqued the militarization of Guyanese society. It is a powerful symbol of the unfinished work of liberation after Empire. Mrs. Persaud's is a singular and refreshing voice. In nearly seven decades of living and painting in Guyana, she has seen it all. British rule. African rule. Indian rule. She refuses to get worked up about the upcoming 2015 national elections in which the corrupt Indian-dominated PPP is being challenged by the multiracial coalition of parties called APNU (A Partnership for National Unity). She finds nothing particularly transformative about any of the choices before Guyanese voters.

But there was once a time when Mrs. Persaud was willing to entertain arguments about the part artists must play in forging political and social change. In those heady days after independence, when the British first left Guyana to the Guyanese, Mrs. Persaud debated with Guyana's Great Men—always men—to redefine the role of art in a newly free society. "For that brief exhilarating moment in history, it did seem that a potent conjunction of poetry and politics could indeed change the world," she later wrote.[5] "Well, we're much wiser now; and we now know that art, as [W.H.] Auden said of poetry, 'makes nothing happen'—especially in our part of the world."

It is not the job of the artist to direct (or join) traffic. The artist must "tilt at the wind," Mrs. Persaud says. The search for a liberating new aesthetic is fine—in theory. In practice, though, she has seen it devolve into an exercise in power and control. Someone would have

to lead and define the aesthetic, and that would mean imposing a "development model" on the artist.

"That, to me, brings to my mind the Chinese Cultural Revolution and the fact that the ministers of the PNC all talked about the Cultural Revolution. It set up a sort of antagonistic energy in me. Cultural revolution? I am not a *cog* in the machine. You are not going to *mold* me! I am not going to be assimilated to your thinking. It is anathema to me. I don't even subscribe to my husband's way of thinking. I will remain distinct. If he thinks *A* I'm going to think *B*. If you tell everybody to wear green, I'm going to wear red. When you try to mold people, and you try to persuade all of them that 'oh, we are all in this collective,' you're gonna find a troublemaker in the midst."

Throughout the afternoon, she delivers a lively seminar on the history of postcolonial art in Guyana. She describes the cast of characters who have influenced her visions on canvas for the past half-century. She is unfailingly polite, speaking in warm and soothing dulcet tones. Her voice is crisp British diction but Caribbean song. The armed soldier who ominously stopped her and a group of children at the entrance to the Guyana Botanical Gardens is the "Gentleman at the Gate." Powerful figures are always "Mr." and "Mrs."—sometimes employed reverently, other times acidly, often mockingly. Mr. Burnham. Mrs. Jagan. Mr. Bush. "You must read Mr. Gimlette's book," Persaud says, referring to a British writer's recent award-winning travel book about Guyana, "the last untamed place in South America." "He wrote it from a white man's perspective. . . . You can get a good laugh."

Mrs. Persaud dishes on colleagues on the board of the Castellani House, where she served for years before stepping down. They are part of what she calls Guyana's permanent "fluttering" class.

These are cultural gatekeepers who often link arms with whatever party is in power at the moment. From colonial times to today, these guardians stand at the country's cultural gates. They are composed of descendants of the same group of people since colonial times: a society of friends that started with white Brits, then the Portuguese, and Africans—especially mixed-ethnicity people. People "like you," Mrs. Persaud says, alluding to my curly hair and skin brightened with shades of my European ancestors.

"You have all these social butterflies who don't know one shit about art. The socialites. They are fluttering. 'This is *fantastic*! This is *wonderful*.'" Through sheer willpower, this mother of two of Indian descent has busted down the gates. She in turn has demanded inclusion for others: women, Amerindians—any original artists—as long as they are troublemakers.

A faint, damp breeze passes through a window covered with wooden slats, hinting at the monsoon that will crash down on us later. There is no air-conditioning in the gallery space, and I wonder what that moisture is doing to the paintings. I can hear riotous flocks of birds (eagles and hawks, parrots, toucans, and owls can be seen in backyards all over Georgetown) singing and chirping around us. During colonial times, the Victorian structure built of local greenheart wood was the home of the colony's chief botanist and named after Cesar Castellani, its Maltese architect. It is from this residence that the botanist designed the landscape architecture of Georgetown, using the rainforest climate to transform the British Guiana capital of Georgetown into what became known as a "Garden City." In 1952, a zoo was added that included jaguar, puma, tapir, white-faced saki monkey, capuchin monkey, West Indian manatees. Also rattlesnakes, spectacled caiman, anacondas, mata mata turtle, and emerald tree boa.

Shortly after 1966, when the Afro-Guyanese founder of the PNC, Forbes Burnham, became Guyana's first leader after independence from Great Britain, he moved his family into the Castellani House.[6] It was here, in 1976, at the building that became known simply as "The Residence" that Burnham hosted a group of top executives from the London-based global sugar conglomerate Booker Brothers, McConnell & Co., Ltd., established in Guyana in 1834. The company had come to control a majority of sugar plantations and acquired a series of businesses in retail, media, advertising, real estate, taxi, and insurance. Booker controlled so much of Guyana's economy (by the late 1960s, it controlled 80 percent of Guyana's sugar estates, as well as retail shops, news media, taxis, and insurance companies) that many bitterly quipped that "B.G." stands not for British Guiana, but "Booker's Guiana." During a series of meetings at the Castellani House, Burnham served these sugar lords twelve-year-old Cuban rum, a gift from Fidel Castro.[7] He then told them that after 130 years of dominating and pillaging the country, it was time for them to get their things and go. He nationalized the sugar industry and took over all the companies formerly owned by the London-based global conglomerate, which had just sponsored the Booker Prize for literature using the spoils from Guyana's earth and sweat.

From the top-floor gallery of the house, you can still see the stables in the back where Burnham kept horses; he was known for making rounds on the vast cane fields he ruled while riding in on a high horse.

The departure of the British and overthrow of the sugar lords evoked a good riddance from Mrs. Persaud. She grew up in the countryside as one of nine children. It was painful to see her father, a schoolteacher and self-described "communist atheist," forced to

kowtow to colonial authorities. "I remember this Canadian Presbyterian reverend—my father hated him. He was responsible for sending messages to [the ministry of education] and reported my father for attending political meetings. The church disciplined him, and sent my father to work in Leguon [a tiny remote island]."

Guyanese of East Indian descent, late arrivals to the colony and carrying with them a distinct and rich culture of their own, they weren't invited into the educational and cultural establishment. Persaud managed to find champions for her work. She jokes that maybe because of her Anglo maiden name (Joseph) the cultural flutterers thought she was of mixed race. One champion was the renowned Afro-Guyanese sculptor and painter Philip Moore (famous for his bronze *1763 Monument* to national hero Cuffy), who taught classes at the Department of Culture. He encouraged seventeen-year-old Persaud's interest in painting and introduced her to imagery of the multiple-armed Hindu goddesses such as Kali. "It was miraculous," she recalls of his lessons. "He said he saw a lot of soul in my work. And when he says something, it's . . . he was like a prophet."

Later, after marrying, starting her family, and earning a degree in English, she began teaching high school. She soon found another mentor in the renowned Afro-Guyanese writer, artist, and anthropologist Denis Williams. Williams made a name for himself as a London artist and taught art in Sudan and Nigeria before being called "home" by Burnham in 1968. "Burnham had his eye on scholars and intellectuals," Mrs. Persaud recalls. Powerful intellectuals such as Williams came back to found the E.R. Burrowes School of Art and Walter Roth Anthropology Museum.[8] As Williams told a group of fellow Guyanese intellectuals during a banquet at Burnham's house, now that Guyana was independent, "Fellas, you now have no excuse for holding another man's passport."[9] As director of

culture, Williams tasked Guyana's artists with the job of inventing a new identity, and casting off the remaining mental chains that brought them all to Guyana. The artist was to play a critical role in creating a vision of a more just and equitable society, and even Mrs. Persaud was excited by the possibilities—at first.

She spent many evenings as a student at the newly formed Burrowes School of Art debating what it meant to have an emancipatory aesthetic. Williams mocked Mrs. Persaud's Guyana landscape paintings, especially her Lotus Lily series, done in bold colors and impressionistic strokes. "'Oh look, that is *real* bourgeois painting,'" she recalls him saying. "I would get vexed with him. I would tell him we don't know what is the bourgeoisie here. All of us have either come out of a slave ship, and the hull from Calcutta, so who the hell are you calling bourgeoisie?"

Mrs. Persaud was then a mother of two small boys, including one born with special needs. (She suspects his delivery via forceps caused the damage.) She had already completed her bachelor of arts degree in English. She stood her ground. The lotus lily is a mystical flower in Hinduism and in Buddhist traditions (and Egyptian history as well). The lily rising from murky waters is a powerful symbol of the possibility of enlightenment, purity, and renewal. "Everybody would admire the realism, but they are not into the philosophical, religious background," she recalls. "I knew I was painting a topic in a very impressionistic manner which was accessible to people and they would like. But at the same time, I knew I was investigating its transient aspect as opposed to its eternal aspect. That is emphasized in the religion, that the lotus is an eternal flower."

Mrs. Persaud was poised to graduate with the Burrowes art school's first graduating class when she got into a small dispute with Williams over her thesis. Like her father before her, she was being

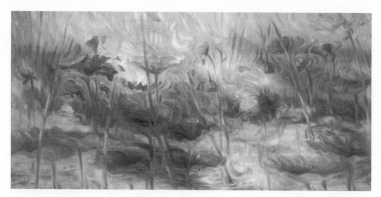

Bernadette Persaud's 1988 oil painting *Lotus of a Hundred Petals* is now in Guyana's permanent collection. Photo courtesy of the Castellani House.

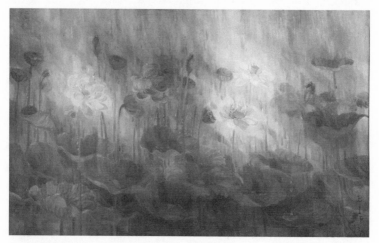

Lotus of July by Bernadette Persaud. Oil. 1991. The lotus is a symbol of purification and renewal. Photo courtesy of the Castellani House.

reported to school authorities for being absent from class because she was participating in meetings and protests for the Working People's Alliance (WPA). The charismatic Afro-Guyanese historian Walter Rodney was leading a multiracial coalition that openly and forcefully challenged the rule of the PNC. Although Mrs. Persaud never joined the party, she did support their efforts to challenge the PNC.

She could have easily acquiesced to PNC party pressure to stay away from WPA meetings and submit her thesis to Williams as she was told. But she was increasingly resentful of the commanding and controlling nature of PNC rule, which invaded all parts of society. Turning in the thesis would have been capitulating. She packed up her things and left. "I said no—to hell with this diploma. I would show them, I was going to be an artist, and they haven't taught me any shit."

In the years after her expulsion, Mrs. Persaud continued teaching English at St. Rose's High School, but her concerns increased about growing authoritarianism. She was glad to see that oppression against Indian students diminished with the government takeover of schools. But that early promise soured when she and the rest of the faculty received letters from the Ministry of Education, instructing them to "address our functional superiors or inferiors as 'comrades.'" She didn't like the mandatory participation in national service, and how it was used to break strikes of sugar workers at government-owned plantations.[10]

She was heartened by the exhilarating rise to power of the WPA's Rodney. He was the embodiment of the troublemaker in the midst. The Black Power radical had caused a ruckus in Jamaica and Tanzania where he published the pan-African canonic text *How Europe Underdeveloped Africa*. When he and his wife Pat returned to their native Guyana in the mid-1970s, the Burnham administration rescinded its offer of a teaching position for Walter at the University of Guyana. A multiracial coalition of supporters (at least half of them Indo-Guyanese) rallied around the family so they could survive while Rodney built the WPA into a political force. Rodney instigated an increasingly bitter public feud with Burnham.

"Walter Rodney was very dynamic," Mrs. Persaud recalls. "It was

a romantic idea I think we all had. The PNC would be forced to give up power. And the day would come when he would bring them down in face of the People's Power. That was the slogan. 'People's Power—No Dictator!' Nobody envisioned any kind of violence."

On one tragic evening in June 1980, Mrs. Persaud stayed late after a school day at St. Rose's, which was festooned with slogans protesting the Burnham regime. The faculty and families of students were showing a film to raise money to help support the Rodney family. Rodney's wife, Pat, was there with their three children. A journalist walked in to announce some troubling news. They stopped the film and sent everyone home. The next morning, all of Georgetown learned that Rodney had been killed in a car explosion. A member of Burnham's PNC army set the bomb. Rodney was thirty-eight.

Rodney's killing was followed by a crackdown on all WPA supporters. Mrs. Persaud got a letter from the education minister (a role filled by Burnham himself), announcing she would be terminated unless she transferred to a school in the hinterlands, away from her husband and family. She packed her things and, once again, walked off the job.

She also kept writing. The *Catholic Standard* published her cultural reviews, which deciphered the meanings of artists who spoke in codes against the Burnham regime. And she kept painting. In her Gentlemen in the Garden series of oil paintings, created in the eighties, the area around the adjacent Georgetown botanical gardens is rendered in technicolor. Behind a lush rainforest-green backdrop, the gentleman's uniform flaps in the breeze, and his camouflage uniform blends into the vegetation. Several white herons are near his feet. French impressionistic strokes render the whole scene in vivid color. It is only when you look closely that you see the outlines of

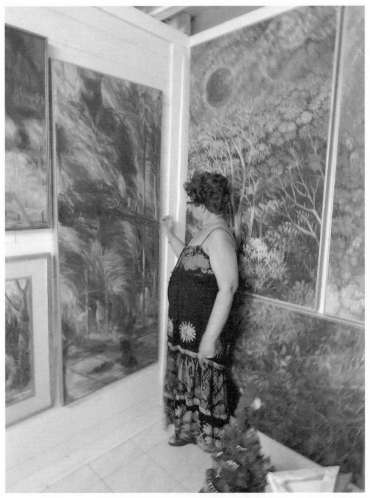

Bernadette Persaud at her home studio outside Georgetown.

the black machine gun that the "gentleman" is holding parallel to the floor.

In a regime that crushed even the hint of public or private dissent, it was a bold critique of the militarization of Guyanese society. This brute oppression had been passed down through colonial-era

military crackdowns and carried on in the first local regimes after independence. The critique was particularly gutsy considering the source: Persaud was an unemployed wife and mother of two. It also launched Mrs. Persaud's career. She earned Guyana's National Award in Art in 1985, the first of a string of awards, exhibitions, and recognition from India, the United States, and Canada and in the Caribbean region.

In Persaud's breakout year of 1985, Burnham died during throat surgery—a procedure attended by Cuban doctors. The Castellani House lay vacant until seven years later when, with the help of former U.S. president Jimmy Carter, Guyana had its first free and fair elections. The American-trained dentist Dr. Cheddi Jagan, the founder of the People's Progressive Party, was elected Guyana's president in 1992. Shortly after his election, his wife, Janet Jagan, suggested that the Castellani House be made into an art gallery. Mrs. Jagan (who briefly took a turn as Guyana's president after the death of her husband) served on the Castellani House's board of directors until her death.

Today the property's horse stables are being used to store some of the twelve hundred pieces in the national fine art collection. On the opposite side of the museum from the stables, a uniformed security guard is on duty. Gentleman at the gate. Mrs. Persaud has invited another important Guyanese artist of Amerindian heritage, Desmond Alli, to join us.

Despite progress, elements of the old colonial structure are intact. For a time Mrs. Persaud served on the Castellani House board with Mr. Ian McDonald ("Man of *Letters*," Persaud says with bite) and Mrs. Janet Jagan, who are both white. Their whiteness gave them a visibly privileged place atop the food chain.[11] As we sit in the museum for several hours on a hot day, Persaud teases the Castellani staff

after they come to check on us: "If Mr. McDonald were sitting here, he'd be sipping his lemonade by now," she says.

One thing I noticed from our many months of conversations, on the phone, by e-mail, and in person, is that despite her bluster, the fear is not something that ever truly leaves. She won't say certain things on the phone for fear her phone is tapped. She still uses a deceptively bold bright color palette that's sure to please even as she lampoons the powerful. Her targets have become an inside joke for the Guyanese intelligentsia in the know. She asks that I don't identify her targets and thus put her family at risk. "I don't want bandits to come and kick down my door," she says. "It would put me in danger."

Today, Mrs. Persaud's political critiques are shrouded in fables of Hindu goddesses and gods, an Islamic series, and an installation of her Hindu prayer flag series. Her focus shifted from guns to spiritual matters, her Indian and pluralistic Caribbean identity, and dimensions of our existence that exceed the human grasp. Her latest Rainforest series of acrylic paintings implants Hindu mysticism in Guyana's natural landscape. This spiritual searching is needed in contemporary Guyana, which struggles with crushing poverty and a loss of hope. It is a country soaked in color and deeply adrift.

Besides the upcoming national elections in May 2015, the current obsession in Georgetown is the hearings for the Walter Rodney Commission of Inquiry launched in 2014. The PPP has loudly trumpeted these hearings, executed at the request of the Rodney family. Although Mrs. Persaud believes the inquiry is long overdue (after all, Rodney was murdered in 1980), she believes the timing is suspect.

"It should have happened a long time ago. Not now. It's just that it is election time, and people are looking at the Walter Rodney commission through the lens of race."

The presidential candidate under the multiracial coalition challenging the PPP is David Granger, an Afro-Guyanese man who was the brigadier general in Burnham's PNC army. By dredging up memories of oppression under the PNC rule, the PPP hopes that the people will forget their abuses of the past several years.

All the rehashing of historical boogeymen adds up to less than inspiring choices. This is the sense of suffocation and frustration that leads so many talented people to flee Guyana, Mrs. Persaud says. "They are the people with initiative. They have abandoned the boat," she says. "I don't have that kind of initiative. I have a child who is handicapped, and it is difficult to move around with a handicapped child. So I will stay put."

She does not dispute the grave need for a change of leadership. "The PPP has been there twenty-flippen years. What the hell have they done but enrich themselves? Who are they fooling? They are not fooling the people." At the same time, the idea of a president tied to Burnham's military regime triggers vivid memories of oppression and suffocation. Persaud finds it particularly ironic that the PPP opposition (which includes the PNC) is using the same slogan invoked by Rodney's WPA: People's Power—No Dictator! "The people know that they have to choose between two evils," she says. "So they will have to choose the lesser evil. I don't know who they view as the lesser evil. I'm looking at the youth vote and what they really think. I don't think they have a clue. There is an amnesia that has been cultivated on all sides."

Whatever the outcome, Mrs. Persaud feels it's time for a new generation of troublemakers to pick up the picket signs. She asks another docent if she has seen today's *Stabroek News*, which has the latest in what the press has dubbed a "Duel with Ruel." Ruel Johnson, the bombastic young Afro-Guyanese poet and Guyana Prize in Litera-

ture winner, is pushing for reforms. Mrs. Persaud agrees reform is necessary. But she has her doubts about how much, if anything, can really change. Regardless of which party prevails, power corrupts. The key players merely change collars under each administration. "They are going to be right there all the time. For the rest of my life, the rest of Ruel's life. He's going to discover that. He's too young to know. He doesn't have the layers."

And with that, today's history seminar is over. No sign of the artist Desmond Alli. The blistering sun has peeked through the clouds after the afternoon monsoon. Mrs. Persaud's husband, Byro, fetches us in their tiny white sedan to take us to New Thriving, a Chinese restaurant, for a late lunch. As we pass the security station near the gate of the Castellani House, the uniformed guard barely acknowledges us. At first we think he has dozed off, but as we pull past him we see the guard is engrossed in his smartphone. It seems the Gentleman is on Facebook.

A street sign in Georgetown, Guyana.

3

The Oasis

This place lost
its poetry too early
replaced with the
pyromania of political will
　　　　—*Ruel Johnson,* A Journal 2002, *Part IV, "Sugar"*[1]

At the Oasis Café on Georgetown's Carmichael Street, patrons munch on biscotti and croissants or sample from a fragrant West Indian buffet: salted codfish and bakes, curry, well-seasoned chicken and rice. Espresso machines hum against walls painted in warm mango tones. Blessed air-conditioning units beat back Guyana's brutal equatorial sun.

A multiracial assortment of café regulars are scattered at the tables. Some work for international nongovernment organizations fighting poverty or preserving the rainforest ecosystem that covers 80 percent of Guyana.[2] There are the usual foreign diplomats you might find in any capital. And then a good number of Oasis regulars are like the writer and cultural activist Ruel Johnson, part of Guyana's fledgling creative sector.

A wiry and intense Afro-Guyanese woman, a visual artist trained in the United Kingdom, whizzes by as she heads out the door. "Hey Ruel [Roo-ELLE]," she says. Ruel returns the greeting with a mumbling diction that belies his crisp written voice. He looks every bit the thirty-something hipster: the requisite not-quite-a-beard is scruffy on his face, and his slightly receding 'fro forms a halo around his prominent brown forehead. His six-foot-tall dad bod is draped in a rumpled button-down shirt and jeans.

An Indo-Guyanese man, his East Asian wife, and preschool-aged daughter smile and greet Ruel as they walk in. The writer holds out both hands to the girl for a lift. She starts to take a step toward him, then shyly demurs, burying her head into her mother's thighs. A University of Guyana economics professor currently on strike over wages chats at a table in grave tones. Ruel introduces me to a dread-locked man sitting across from the professor who sighs that he's "unemployed!" in a way that sounds like a relief.

I first came to the Oasis shortly after meeting Johnson in the summer of 2011 when I was on an extended family visit. The Oasis Café was one of many delightful corners of Georgetown he hipped me to. I was instantly tuned in to an upbeat, progressive frequency that belied the poverty and deprivation that envelops much of George-town. My relatively pampered American preteen children reveled in the café's rare-for-Guyana comforts such as free WiFi. "It's really an oasis!" they say in sincere gratitude each time we come.[3]

Although Georgetown is a tropical city located at the northern edge of South America, culturally it is part of the English-speaking Caribbean. The city of 124,000 is an urban outpost surrounded by pristine Amazonian jungle, but it is not the tourist trap one might imagine. Starving dogs, and the occasional cow and horse, roam city blocks. Originally, the city was carved from several plantations

as a British military port known in British Guiana times as "Garden City."[4] Today, Georgetown, the capital of Guyana, is covered in piles of trash. Residents and visitors have spent years waiting for sober heads to prevail in contract disputes with sanitation workers. The pervasive stench of garbage is an apt expression of dysfunction between the Indo-Guyanese majority that holds federal power, and the Afro-Guyanese who would hold urban power.[5] Guyana's two largest ethnic groups are the feuding couple so consumed with hatred for one another that they don't bother to change out of their blood-splattered shirts for company.

When I return to the Oasis after attending Mashramani, a couple months before Guyana's national elections in 2015, I am relieved to see the café is still living up to its name. At the table at the back of the restaurant, Ruel takes a seat and fires up an old MacBook Pro to monitor election news and interact with his five thousand followers on Facebook. He is the cultural policy advisor to A Partnership for National Unity (APNU), a multiracial alliance of parties challenging the People's Progressive Party (PPP) that has ruled Guyana for twenty-three years.[6]

Ruel coaches the young people in APNU on how to use social media to challenge the party that controls 80 percent of the economy and most mainstream print and broadcast media. "Every lie they try to tell there is being countered," Ruel types. "They seek to challenge or undermine their most effective Facebook critics. It's a strategy of desperation. Tackle them hard on issues."

Born in 1980, Ruel first exploded onto the Caribbean literary scene when he became the youngest-ever recipient of the Guyana Prize for Literature at age twenty-two. His debut work, *Ariadne and Other Stories*, was awarded a $5,000 (USD) purse, which was among the largest cash literary prizes in the Caribbean. Ten years later,

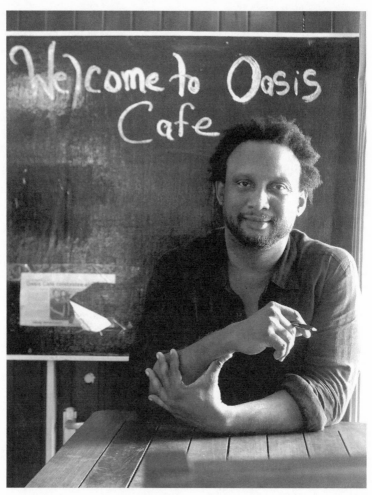

Guyana Prize–winning writer Ruel Johnson is dreaming of a better Guyana. Photo by Akola Thompson.

he accepted another Guyana Prize for his next collection of short stories, *Fictions*, and his collected poems won a Small Axe Award in 2013.

Ruel's fiction and poetry probe the interior lives of Millennials born a generation after independence. Like him, his African-,

Indian-, and Amerindian-descended characters have a droll detachment from the absurdities of their condition. They make allusions to Jorge Louis Borges, listen to Kenny Rogers and Lauryn Hill. They make love to the Other, play football, flirt on Gchat, parent obsessively.[7]

But Ruel's literary acclaim has been greatly eclipsed by his epic letters to the editor in Guyanese newspapers, and caustic cuss downs on Facebook. Across the Caribbean diaspora Ruel is known for tagging and sucker-punching Guyana's elected officials with bracingly blunt critiques of incompetence, corruption, and, sometimes, just stupidity. These days, he is completely consumed (his girlfriend, a German anthropologist, fears dangerously obsessed) by the upcoming national election. It's the second election cycle in which he's served as a cultural advisor to the opposition aiming to depose the ruling People's Progressive Party. They narrowly lost last time in 2011. He is convinced the second time is a charm. "Now these people—they have to go," he says.

His loved ones have reason to worry. There is a tragic history of activists being killed for pushing things too far in Guyana. The most prominent killing was the car bomb murder of Black Power scholar Walter Rodney (described in chapters 2 and 6). Rodney was certain that a regime change was imminent when agents of the African-dominated People's National Congress (PNC) killed him in a bomb explosion in 1980. More recently, the successive ruling party, the Indian-dominated PPP, has tried to use the threat of violence to silence people. President Donald Ramotar told a teacher in an Amerindian village who criticized the PPP leader Bharrat Jagdeo: "You don't know anything about Jagdeo; if he been here, he might have slap you, cause you stupid." According to the teacher, that's exactly what presidential guards did—injuring his mouth.[8]

A recording of Attorney General Anil Nandlall threatening to murder the publisher of one of the major daily newspapers and warning a reporter that it was not safe to work there was posted on YouTube.[9] There were no repercussions for this behavior, even after the attorney general admitted it was his voice on the tape. This total breakdown of accountability among the country's media, justice, and political systems led some individual citizens to try to take things into their own hands. Courtney Crum-Ewing, an Afro-Guyanese activist and forty-year-old father of three, staged a one-man protest in front of the attorney general's residence for months. Crum-Ewing marched in front of the residence waving picket signs and shouting through a bullhorn, urging people to vote against the PPP. Crum-Ewing boldly spoke out at a time when the growing coarseness and viciousness of the PPP's attacks—and their lack of consequences—made everyday Guyanese afraid to speak out for fear of reprisal or even physical harm.

Ruel waves off these concerns. He believes all is within his grasp: a literary career, racial harmony, *and* a political coup. But each of these tasks may be easier to pull off than his other dream: a viable, self-supporting creative sector in Guyana. Ruel has a vision for a transformed Guyana: with prosperous literary, music, and visual arts sectors. Guyanese lush rainforests coveted as locations to shoot film. A regional hub of creative industries clustered across the three Guianas (former Dutch, French, and British colonies) and the Caribbean. "I see tremendous potential in Guyana," he says.

To bring this vision to life, Ruel has founded a series of organizations including a writers' guild, publishing company, editorial services—all with the Janus label. ("I am Janus—the god of new doorways and new beginnings.") Most recently, he launched the Janus Cultural Policy Initiative to develop an arts-based plan for

Guyana's development. "If our problems are, at core, cultural, our solutions must be cultural as well," he says.

If sugar represents Guyana's past, he believes the arts are the catalyst for a new kind of future. "For emerging economies such as ours, we simply do not possess the economies of scale to compete sustainably in a global free market system when it comes to the production of certain primary products, like sugar for example," he wrote.

"What we do however have a monopoly on is a unique cultural heritage, which we can consolidate, develop and transform—where possible—into the creative industries that are a crucial part of the contemporary global economic pie."[10]

Art, Ruel believes, *can* change something here. It can transform Guyana's economy.

He's all swagger and certainty—even in the heat of the fire. And by fire, I don't just mean the metaphorical kind. Days ago, the Janus Cultural Policy Initiative published an investigative exposé of corruption at Guyana's national museum. The same morning the investigation was published online, a mysterious fire was set at the museum. So when a thirty-something Indo-Guyanese woman who works for the cultural ministry at the museum walks into the Oasis and hands him a USB flash drive filled with government documents, I start to worry. As the museum worker and Ruel explain, the documents expose more corruption in the cultural administration. He plugs the drive into his MacBook to start the download. I steal a quick glance over my back.

Georgetown is just one of many hard-luck urban areas around the world searching for a way forward. In struggling cities like Detroit, the Liverpool-Manchester area in the United Kingdom, Ivanovo in Russia, and the Halle-Leipzig region in Germany, there have been

movements to rethink urban models. This involves thinking equally about how cities thrive and grow as well as how they may even be allowed to die, according to the groundbreaking international Shrinking Cities initiative sponsored by the German Federal Cultural Foundation.[11]

When the focus is on growth and regeneration, the arts are often the first place urbanists go for inspiration. This is how a narrative around arts and culture—not just for their own sake, but as a *tool* in service of economic development—has taken hold. The boom years after World War II saw the iconic image of cigarette-waving Beat poets chasing their bohemian muse in the gritty inner bits of New York City and San Francisco. Outlaw artists challenged sacred social conventions in their lives and their writing. Writers like Allen Ginsberg, Jack Kerouac, and William S. Burroughs embraced the city in all its color, sexual diversity, and vitality. This romantic image of the urban bohemian beatnik was in sharp contrast to private and public policies of the time. The new post–World War II prosperity was targeted at building "white" spaces outside the urban centers and inoculating them from the servant caste of people of color. In my previous book, I called these segregated American urban spaces led by black political leaders and starved of investment "Chocolate Cities."[12] When people of color took leadership of many of these cities, these victories were high in symbolism. Self-determination is priceless, but these political victories turned out to be somewhat of a hollow prize given the extent to which their economies were simultaneously deflated. Adding insult to injury, these basic economic inequities are attributed to failures and incompetence on the part of the leaders of color who preside over these divested communities.

This basic development pattern also applies across the globe. As Europe decolonized, investment for infrastructure and development

was abruptly withdrawn from newly independent countries like Guyana, now led by black and brown leaders who were economically marooned after independence. The historian Walter Rodney's classic text, *How Europe Underdeveloped Africa*, explicates this phenomenon in the former colonial world across the African continent. He argues that the economic, educational, and social systems in these colonized African societies are designed to be dependent on the former metropoles in Europe who continue to pull the financial strings after independence.

In the United States, the narrative of white urban escape was greatly shifted by the legendary urbanist Jane Jacobs's full-throated defense of the value of city ecosystems, *The Death and Life of the Great American City*, first published in 1961. Jacobs's vision came to vivid life a generation later, when in cities such as Manhattan, San Francisco, and Seattle, the artists arrived first, moving into decrepit neighborhoods and abandoned buildings in the urban core, finding inspiration and a palette for personal and social transformation. Other creative professionals followed. A concentration of workers living, working, and playing together in these urban wonderlands are credited with helping to fuel lucrative innovations in the financial, creative, and technology sectors.

The social and economic quarantine on poor and often-racialized localities has begun to lift as the arts and creative industries have been identified as an untapped resources to grow cities.[13] By the time economist Richard Florida released his book *The Rise of the Creative Class* in 2002, many policy makers had accepted a new narrative about underdeveloped locales.[14] Florida's charts and regression analysis, his "Bohemian Index" and data sets, appeared to *prove* that districts with progressive policies, high levels of tolerance, gay couples, artists, and knowledge workers in what he called the "creative class"

were the engines driving the economy of the future. Clusters of art-
ists and creative and knowledge workers sprinkled magical innova-
tion dust in neglected spaces.

At the time of the publication of *The Rise of the Creative Class*,
social science and public policy favored quantification over nar-
rative; no one believed anything unless there was a spreadsheet
attached. The data may have made policy makers and investors pay
attention. However, the beauty of Florida's vision was not that it
offered quantitative "proof." As it has been said, if you torture num-
bers long enough, they tell you whatever you want. Many critics
challenged Florida's math and questioned whether concentrations
of creative workers *cause* innovation and wealth, or whether there
is simply a *correlation* of concentrations of creative workers with
wealthy economies.[15]

The true power of Florida's *Rise of the Creative Class* was that it was
a story—with a simple beginning, middle, and end—that concluded
triumphantly with visionary policy makers winning the economy of
the future. Rising powers in India and China were recalibrating the
value of labor across the globe, just as slave-driven economies once
did centuries before. The task now was to leave behind what the
ethnomusicologist Carolina Robertson called the "table world."[16]
The "old" economies were built on manufacturing, agriculture,
things you could touch, which yielded profits that were consider-
able, but stagnant. The rise of the "creative class" was a pivot to the
future—economies built on ideas, innovation, software, experienc-
es, applications—and art.

These "products" have no intrinsic, essential, or self-evident value
outside what others can and will pay. The value of creative com-
modities is socially constructed. But payment is in real dollars. Cre-
ative industries are among the fastest growing sectors of the global

economy. In the United States, the entertainment and creative sector grew from $64 trillion in 2001 to $104 trillion in 2010, growing far faster than "table world" goods. In the United States, the sector employs 1.3 million people, and roughly the same number of people in the United Kingdom.[17] The entire sector is more valuable than the automobile, agriculture, or aerospace sectors, according to a Price Waterhouse Cooper study.[18]

The rise of the creative class is an inspirational tale about how mining the ground for cool, smart people is the key to future riches. Cities all over the United States, Canada, and Europe did their own versions of Florida's charts and worked up strategies to compete in the global economy by developing and attracting these knowledge workers. In recent years, social scientists have applied Florida's theories to the development of places like Guyana.[19] Two United Nations researchers, Diana Barrowlough and Zeljka Kozul-Wright, of the United Nations Conference on Trade and Development based in Geneva, Switzerland, published *Creative Industries and Developing Countries: Voice, Choice and Economic Growth* in 2008, which mixed case studies and Florida's theory to make a case for the importance of nurturing the creative class in developing countries. Case studies examined policies that led to the growth of the creative sector in the Indian and Senegalese film industries, Caribbean and Brazilian music, the software and publishing businesses in the Arab world. In the most dramatic example, government investments in acrylic paintings by indigenous tribes of Australia, when coupled with policy support and public investments, grew into a sector worth hundreds of millions of dollars, larger than the country's bauxite industry.

Still, aside from the indigenous Australian example, which relied on the Australian government and connections to billionaire art col-

lectors for success, there are very few straight lines from a policy to results. The case studies are filled with descriptions like "possibility," "potential," "unrealized," and random invocations of the Internet. Believing that investments in the cultural sector of developing countries will transform their economies remains an act of faith. But this narrative is especially appealing to abandoned former European colonies such as Guyana, suffering poverty, crumbling infrastructure, and brain drain. Why not leapfrog over the industrial phase of development and parachute directly into the global ideas marketplace? It worked for Singapore, which trailed Guyana pre-independence in terms of its economic output but has become a Cinderella story in the decades since. Singapore went from $320 GDP per capita in 1963, the year it gained independence from Great Britain, to $60,000 GDP per capita in 2015.[20]

As Ruel likes to say: "Innovation costs us nothing."

The erudite and charismatic Ruel Johnson is the perfect person to spread the gospel of cool cities in Guyana. He networked at Carifesta, a regional cultural festival among Caribbean countries, when it took place in Suriname, spent time in Europe with his girlfriend who was studying in Germany. At a conference in Europe, Ruel made some connections who encouraged him to apply for a grant with the Prince Claus Fund for Culture and Development, based in the Netherlands. Thus the seed money to support "Culture in Defiance" helped launch the Janus Cultural Policy Initiative in 2014.[21]

Through the initiative, Ruel has been holding meetings all over Guyana. His Oasis Café crew has held public meetings to explore issues such as heritage and preservation, race and cultural difference, and intellectual property. A multiracial group of trendy young people camp out in his apartment, talking about creating a network of creative spaces around Guyana. They've transformed the space

into a "war room" with charts, cardboard cutouts, and printouts of tables and schedules of how they will make this vision of a cultural industry in Guyana come to life.

It's a tough sell to invest in the arts in a country where children lack electricity in some villages and teachers make $200 per month. But their vision is no more improbable than the Oasis Café itself—which brims with creative energy every day. It's about creating a space where unscripted interactions might happen. It is seizing the moment in which democratization of information via the Internet helps them float above immediate racial and ethnic divisions and narratives of the past. Ultimately, cultural development goes beyond an economic return; it is an investment in the voice of a nation, and faith in the crucial role that artists play in articulating that voice.

Artists are the ones who can see a reality that is not currently staring them in the face.

The question is, can they survive the realities staring them in the face?

Back at the actual Oasis Café, Ruel is sitting near the back. It is air-conditioned and cool here. But the closer we get to the national election, the more the vibe around town gets claustrophobic and tense. People regularly stop Ruel on the street to pick up the string on a conversation he started on Facebook or in his letters to the press.

Anxiety about what will happen on May 11 seems to underlie every conversation and interaction on the street. More than one person tells me they are trying to avoid talking about it altogether. But it is the elephant in the room.

When I see Ruel out in Georgetown, I urge him to change seats so that we can both face the door. I am not an easy-to-scare person, so I can't explain why I am constantly watching my back. The

thirty-something Indo-Guyanese museum worker with the flash drive sighs as she takes a seat at a table. "The museum is going down the drain," she says. Priceless artifacts such as the oil portrait of Queen Elizabeth and Prince Philip given to Guyana at the time of independence are being destroyed through neglect. "These are not things you can replace," she says.

Both Ruel and his informant are still feeling the heat from the last investigative exposé, "Twilight at the Museum,"[22] published on the new web portal *The Mosquito*, launched in collaboration with the Janus Cultural Policy Initiative. The report detailed the graft in contracting for the historic museum. The series included documentation of a no-bid multimillion-dollar (GYD) museum-digitization contract awarded to a questionable company run by a relative of the administrator in charge.[23] The morning *The Mosquito* published its "Deep Sting," there was a mysterious arson at the museum.[24] The informant's museum bosses, who already suspected she was the source of the leak to *The Mosquito*, blamed her for the fire.

Improbably, here she is, sitting with us at the Oasis Café, in plain sight. She tells me she's not worried about being seen publicly here with Ruel. "I can trust him with my life," she says. "You can see how deep that is."

Her outrage is deeper than her fear. She's tired of the inflated expense accounts with bogus charges for taxis and stamps, no-bid contracts to family and friends, and staff padding project budgets to pay themselves. "This is what I am seeing," she says. "They keep emptying the money." Most unacceptable to her, this "thiefing" was happening as the museum was in dire straits. Water had damaged the building housing the collection and valuable artifacts.

She had tried to raise her concerns about the museum through conventional channels. She said her bosses at the culture ministry

swatted them away. Both the president and the attorney general personally called her and told her to back off. She did not take this lightly since both of these public officials had threatened other citizens with violence in broad daylight.

"I am feeling small," she says. "I am highlighting these things and this is the type of feedback I am getting."

She turned to Ruel, whom she had met at a cultural event. If she wanted to stick her finger into the hornet's nest, this was exactly the place to go. Ruel was in the middle of an increasingly vicious grudge match against her boss, Frank Anthony, who as minister of youth, culture, and sport is one of the country's most powerful artistic gatekeepers and responsible for setting Guyana's cultural policy.

For years, Ruel had been badgering the ministry to give emerging writers access to the government-run Caribbean Press, and also pushed for printing to be done in Guyana instead of abroad in London. One of the culture ministry's editors responded that he refused to publish the "doggerel and puppyrel" submitted to him by Guyanese writers.[25] When Ruel learned that one of the two publications the Caribbean Press awarded to emerging writers went to Anthony's thirteen-year-old daughter, he logged on to Facebook, and then went apoplectic.[26]

"The Minister's most unfortunate misstep in this is that he has tainted the first efforts of what may well be a talented young writer, his own daughter, with the stain not only of nepotism but corruption," Ruel wrote. "It does not matter how good her book may be." "[She] now has to live with the fact [that] her debut novel has all the stink and stigma of the PPP's shameless sycophancy upon it."

A stunned Anthony hired a Park Avenue, New York, law firm to write a letter demanding Ruel cease and desist in this line of attack; Ruel replied publicly that the minister could try legal action, but he

should be prepared to expose every single aspect of his ministry's finances during a trial.[27] In early 2014, as the debate continued to gain traction, Anthony broke his public silence in a letter responding to "the irrational, malicious, divisive, distrustful, ill-will and nonsensical ranting of Mr Ruel Johnson."[28]

"The man has become my lone critic, his voice ringing loud with malicious discontent against my work. No Minister is answerable to Ruel. Instead we are answerable to Parliament. . . . As Minister, I cannot spend all my time babysitting a juvenile literary figure who thinks the world revolves around his contributions."

Ruel clapped back: "The Minister keeps forgetting his place as a public servant and thus somehow feels he is not answerable to a member of the public, or civil society, or the media, none of which occupy directly any seat in Parliament.

"I have repeatedly accused him of being incompetent and obfuscatory and his letter only gives further confirmation of that; if it is that he cannot withstand scrutiny, I repeat that he should resign and rest assured that my attention is going to be focused on whomever it is that he is replaced with since my concern remains the poor execution of cultural policy under this government," Ruel wrote.[29]

As the 2015 election approached, Ruel ratcheted things up even further on *The Mosquito* (tagline: "they move fast, sting hard and you can never get rid of them"). Within thirty days, the site's blend of commentary, satire, and investigative reporting had garnered more than one hundred thousand page views. Ruel is also advising an active Facebook group, Youth Moving Forward, comprised of young people of many races.

In the previous, 2011, election, the opposition failed to overcome the demographic advantage of the ruling Indian-dominated People's Progressive Party. This time, Ruel is certain reason will prevail

among a new generation of voters (recall, 60 percent are under the age of thirty-five) who are ready to make a historic break from the racial gridlock of Guyana's past.

The museum worker agrees. "A lot of young people are seeing for themselves what the government is doing," she says. "They see the government driving a new car every week, and you have to walk in the sun." They have to pay taxes. She says that many of her peers are just "drifting away" from the PPP.

Sitting here at the back of the Oasis Café, my paranoia cranks another notch when I learn that Ruel also faced an internal threat at Janus. One of Ruel's collaborators, a young Indo-Guyanese woman he'd hired to work on the project, had quietly begun approaching his other Indo-Guyanese allies (including the museum worker) and asking them to hand over all project documents.

Ruel figures his former colleague has been bought off.

"You can't trust the person," the museum worker says.

"You can't trust anyone," Ruel agrees.

It is very intimidating to go against the government when it controls 80 percent of the economy. She has a good government job. If the PPP is reelected, what will happen to her career?

"I don't think about that," the museum worker says. "I was just so obsessed with this museum. . . . We gon' get a change soon, right Ruel?"

"Of course," he replies.

Two weeks after I sat down with them at the Oasis Café, I get some disturbing news from a cousin, Shoundelle George, a student at the University of Guyana, that makes me wonder if this kind of confidence is justified. My cousin shares an update about Courtney Crum-Ewing, the political activist who had been staging a one-man protest in front of the residence of the attorney general, Anil Nandlall.

Nandlall had acknowledged his voice was on the tape threatening the life of a prominent newspaper publisher. Crum-Ewing reported to police that he received threats, too. But this did not stop him from taking to the streets in front of Nandall's office each day for hours, with placards bearing signs: "Anil Must Go!" "Yes Democracy. No Class/Race Domination." And "Anil! You Spoke. Now I Speak for the Masses In Jesus Name: Go! Adios! Allez!"

On March 10, Crum-Ewing was holding a bullhorn and urging people to vote, when a car with four men drove up and fired multiple shots at him. The activist was hit five times, three shots to the head and another at point-blank range behind his neck.

As the election approached, Amnesty International made a statement expressing doubt that Crum-Ewing's case would get justice.[30] "Given the sensitive electoral context and the police's poor record in solving high-profile murder cases, there are fears that this killing might exacerbate political tensions, spark further violence and have a chilling effect on freedom of expression," they wrote in a March 17, 2015, statement, "URGENT ACTION: Political Activist Killed Ahead of Elections."

In a photograph widely circulated online, Crum-Ewing lay sprawled across Third Avenue in Diamond, the upscale district where the attorney general lived. He wore a black cap, black shorts, and bright yellow polo shirt. A few feet away from his bloody body, his white bullhorn lay silent.

Kara Walker's Sugar Sphinx drew hundreds of thousands of visitors in 2014 to pay tribute to the women who labored to build empires. Photo by Dan Nguyen. Creative Commons.

4

Sweet Ruins

Like a web
is spun the pattern
all are involved!
all are consumed!

—Martin Carter[1]

Inside the abandoned Domino Sugar Refinery in New York, the first thing that hits you is the smell: over a century's worth of industrial grime, clinging to black, molasses-coated walls. At first whiff, it is kind of sweet, like stale cake. As you go deeper into the cavernous brick building, it gives way to a sour curdling. As my ten-year-old daughter, Maven, describes it: "It's like how my cat smells when he throws up."

Maven, my friend Izetta, and I are among more than a hundred thousand people who make a pilgrimage in the summer of 2014 to pay homage to the "Sugar Sphinx," the seventy-five-foot-long, forty-foot-high creation of Kara Walker, one of the most important and provocative artists working in the United States. The sculpture is forty tons of sugar molded into a ghostly white apparition,

part mammy, part sphinx. The line to see her takes more than an hour to travel and stretches out for four long Brooklyn blocks. I spot the writer Gaiutra Bahadur, whose recent book, *Coolie Woman,* explores the history of indentured sugar workers in Guyana.[2] Bahadur's research on sugar plantation life and its bitter aftertaste among Guyanese women speaks forcefully to the exhibit we came to see. I wave Bahadur over to join us in line.

The installation's title, displayed in bold black type painted along the Domino Sugar factory's brick façade:

A Subtlety

or the *Marvelous Sugar Baby*

an Homage to the unpaid and overworked Artisans who have refined our Sweet tastes from the cane fields to the Kitchens of the New World on the Occasion of the demolition of the Domino Sugar Refining Plant

The original Domino factory—first built in 1850s Williamsburg—was being torn down, along with the stories of generations of lives that it touched around the world.[3] The factory was just one stop in the sugar industry's "triangular trade" that created the blueprint for the globalized economy. Investors came from Europe; labor came from Africa; the cane fields were located in points across the Global South. The Domino refinery was the final step before the sugar reached consumers. Raw sugar would arrive at Domino's forty-thousand-square-foot facility. Through the magic of refinery, pristine white sugar would come out. The profits that followed made sugar a key fuel of Empire.

The title, *A Subtlety*, is taken straight from history. Centuries ago, "subtleties" referred to elaborate, edible toys made of sugar. These exotic treats and status symbols were first made in the Middle East and popularized among the seventeenth-century European aristocracy. These "subtleties" could be trees, architectural models, or depictions of peasants holding baskets of fruit. There was nothing subtle about them, given what a rare and expensive luxury sugar was at the time. Unveiled at dinner parties, these were ostentatious displays of the host's clout. The sugar sculptures could also be used to send more subversive messages. "Sly rebukes to heretics and politicians were conveyed in these sugared emblems," writes Sidney Mintz in *Sweetness and Power*.[4]

Kara Walker is a MacArthur genius known for her black-and-white palette and raw, sexual reenactments of American history. The artist seized the occasion of the demolition of the factory as an opportunity to invite the public to consider sugar's history of power, conquest, luxury, and sex. Walker directed a small army of artisans over several weeks to construct her vision of the Sugar Sphinx. The National Endowment for the Arts, Domino Sugar, and the private gallery Sikkema Jenkins & Co. were among the sponsors lined up to support the production. It is the kind of razzle-dazzle spectacle only possible in a country with food to spare.

Admission to the installation is free. We are encouraged to post responses under the #karawalkerdomino hashtag. That made participants an essential part of the artistic performance. We don't just *remember* the sexualized horrors of plantation life; we are participants, co-conspirators, and consumers.

Inside the old factory, we follow a trail of "sugar babies," life-size statues of brown boys rendered in brown sugar, shirtless and covered in loincloths, carrying baskets, also created by Walker. They are

arranged as though cutting a path in the fields on the way to their mother. We snap a photo of my friend Izetta, who is less than five feet tall, head-to-head with a sugar baby. One sugar baby's basket is tossed over his shoulder. Another balances his basket on his back. Their smiles aim to please.

Soon, though, we see that New York City's July heat has brutalized some of the sugar babies. One has collapsed in a puddle of black syrup. His creepy light smile is perfectly preserved, as his body parts lie violently askew. It looks like a crime scene. We see another fallen sugar baby: a massacre. My daughter Maven snaps more photos with her tablet.

Then we reach the Sugar Sphinx herself. As per all monuments, she commands authority through sheer scale. Crouching at forty feet tall, her firm breasts and large white areolas stand at attention. She has the same African nose and imperious cheekbones of her creator, Walker. Wide eyes stare off into the distance, blank as the Egyptian. Her lips met into two thick bows. Her expansive nose tilts upward. Nostrils flare with delicious impertinence.

A wide handkerchief covers her head and knots above her left eye, a crown. Leaning regally on front paws, her countenance is that of the imperial lioness yawning at her place atop the food chain. *Bow down, bitches.*[5]

People scope out places to take selfies all around her meaty limbs, carved in the fertile curves of a hip-hop video vixen. All around us, cell phone cameras pop off everywhere. The crowd forms several small bottlenecks at the back, where her feet are tucked beneath a rear end arched impossibly high. When we do arrive at this final destination, everyone is caught off guard by the sculpture's level of detail; it is easily the largest vagina any of us have ever seen.

A black woman wearing sunglasses, a curly weave, and a long-

sleeved body-hugging dress works on a pose for her #karawalker-domino response. A thirtyish dreadlocked black man in a red shirt stands ready with an iPhone and telephoto camera to snap the woman, who faces us with her back to the Sugar Sphinx, and raises clasped hands up over her head. When the model's index finger stops bull's-eye on the Sugar Sphinx's long, meaty labia, the photographer gestures for her to freeze.

He gets off several snaps of her manually penetrating the Sugar Sphinx with her index fingers. He's just getting warm when an exhibit volunteer, a twentyish white woman wearing a CreativeTime T-shirt, intervenes. She exchanges a few words with the model I could not hear, and the photo shoot is over.

I ask the model what happened. "She said that's not allowed," she tells me, gesturing toward the sweet pussy behind her. "I mean, what

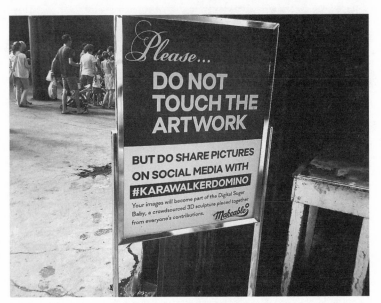

Visitors were not just spectators, but participants in the public installation. Photo by Maven E.H. McGann.

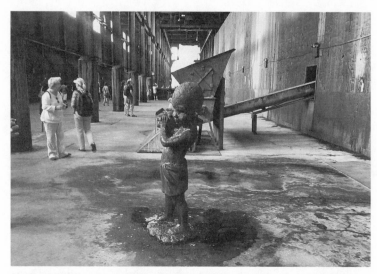

The Sugar Babies arrayed along the path to their mother. Photo by Maven E.H. McGann.

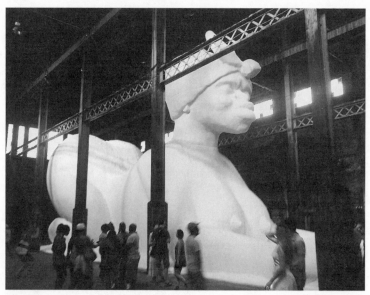

The crowds interrogated every curve and crevice. Photo by Maven E.H. McGann.

else were we supposed . . . " The dreadlocked director gives a smirk. "I guess it's . . . *un-American* . . . or something," he shrugs.

We have come to expect bizarre reactions from sugar. It is sensory and symbolic overload. Refined sugar was first marketed as a drug. Processed and presented as a gift, it expresses love and promises carnal pleasure. The history and ongoing agony caused by sugar are mostly hidden from public view. Its sexual brutality is shrouded by amnesia and silence. Much like the twenty-first-century costs paid for smartphones, cheap clothes, and disposable trinkets, it's out of sight, out of mind. For those of us with roots in the Caribbean, our destinies were shaped by the demands of sugar and plantation life, and the historic moment in the eighteenth and nineteenth centuries when they became engines for Western empires. Our domestic lives are still being shaped by the culture of domination that took root in those fields.

"The slave trade, sugar's sickening by-product, would eventually claim its place alongside the Gulag, the killing fields and the concentration camps as one of the greatest atrocities in human history," Andrea Stuart explains in *Sugar in the Blood*. The "triangular trade" system between the sugar estates in the Global South acted as a buffer between European and American consumers and the brutalities that produced them.

European powers were not totally ignorant of the moral hazards involved. Speaking in 1563, Great Britain's Queen Elizabeth I warned that "if any Africans were carried away without his free consent it would be detestable and call down the vengeance of Heaven upon the undertaking." But as Stuart writes, sugar profits helped the English forget, and ultimately led them to become the "greatest slaving nation in the world." Slavery drove down prices and expanded

access beyond the elite with the leisure and wealth to amuse themselves with "subtleties."[6]

Writing more than two hundred fifty years ago, the French novelist Voltaire noted the gap between Western material comforts and the price paid for them in his darkly satirical travelogue *Candide*.[7] The protagonist meets a Guinean-born enslaved man in Suriname (Dutch Guiana) who is missing an arm and a leg. The worker explains that he lost an arm in the sugar mills; when he attempted to run away, his Dutch master cut off a leg. "This is the cost of the sugar you eat in Europe," the enslaved man explains.[8]

As sugar became a mass product, it became a dietary staple in Europe.[9] Like tea, "sugar came to define the British character," Mintz notes. As the masses became addicted to sugar, profits exploded. Sugar generated piles of cash for the European and American investors. Slave labor is what made this transformation from a precious luxury to a mass product possible.

The history of Haiti, the only country poorer than Guyana in the Americas, is also a story of sugar. At the time Haiti liberated itself in 1804, it was the French Empire's top sugar producer.[10] It seems the global economic powers have not known what to do with these former sugar colonies outside this paradigm of domination and exploitation. Many of the atrocities that followed Haiti's liberation were bald attempts to dispose of these former workers and their descendants, now considered superfluous. In 1937, Dominican Republic dictator Rafael Trujillo (also known as "El Jefe") ordered the murder of tens of thousands of migrant Haitian sugar workers. Edwidge Danticat fictionalizes this massacre in her dazzling 1998 novel *The Farming of Bones*.[11] Through exhaustive historical footnotes Junot Díaz tells the story of this massacre, which cursed successive generations of Dominicans, in his masterful *The Brief and Wondrous Life of Oscar Wao*.[12]

Even less visible still are the narratives that spring forth further down the Atlantic. These true tales strike at the deeply gendered nature of plantation exploitation that Walker's installation so vividly brought into focus. On sugar plantations, African enslaved women were always greatly outnumbered by men of all races. Their sexual attention was in great demand, as black women greatly outnumbered white women as well. As many of the colonies were being established, ratios of 100 men to 1 woman were not uncommon. The lack of available female partners left these societies in a "feral state" leading to bestiality and other debasement, Stuart notes. Worker living quarters allowed no sexual boundaries within families forced to share cramped spaces. On plantations in the American South and the West Indies, it was common for white men to sexually brutalize black women. Many American plantations were often owner-occupied and the owners lived among a society of other whites, where cultural norms encouraged them to be discreet in their sexual relations with enslaved women. In the West Indies, where more of the planters were absentee owners, a more freewheeling sexual culture took hold. It was common for white men and overseers left to manage the plantations to sexually brutalize enslaved women, and few bothered to hide it. "White men extended their dominion over Negroes to their bed, where the sex act itself served as a ritualistic re-enactment of the daily pattern of social dominance," as one scholar noted.[13] The emerging mulatto class in both the American South and the West Indies visually attests to this norm. My own origins may be traced to such liaisons. At the time of emancipation, one British Guiana owner named John Hopkinson had willed his estate, including the £36,270 reparation payment approved by the British Parliament for 713 slaves, to his nine children he fathered with two mulatto sisters.[14]

Enslaved black women were expected to work the fields as a man, take floggings as a man, and make babies like a woman—often at the same time.[15] Under Dutch rule in the Berbice colony in present-day Guyana, plantation owners clung fiercely to their independence and rejected any attempt to protect the welfare of slaves. Many Caribbean planters eventually acquiesced to policies regulating the number of lashes allowed as punishments. Some historic accounts nonetheless have Guyanese women and a girl as young as seven years old taking hundreds of lashings during a single punishment.[16]

British planters took control of the plantations in Guiana, with many switching from cotton and tobacco to sugar to ride the boom. One planter lamented his limited choices in trying to discipline women: "It became clear that planters, should they be deprived of the whip over women, felt they had not alternative to solitary confinement."[17]

Gendered oppression did not stop in the fields. In the frenzy over getting a piece of the £20 million bailout to slave owners, the widow of Rev. Simon Little, stationed in Jamaica, pled for higher payout on those grounds. The widow had been living in England off the proceeds from fourteen urban slaves she owned in Jamaica. Mrs. Little feared they would not fetch top dollar from Parliament because "out of the number, 10 were females, but from that circumstance, they have more than doubled their original number, and of course doubled my income. I speak strongly on this subject as my existence depends on the rent of these few negroes and what am I to do when seven-eights of my income are taken away?"[18]

Enslaved women were often prostituted to raise more money for plantation owners and overseers. Their poor health led to low fertility levels, and many enslaved women also sought to get some control of their bodies through abortion. The few white women in residence on

the colony were often just as brutal toward enslaved workers. However, rape of white women was also a tool of revenge by black men.

A narrative of gender domination runs through one of the most triumphant plots in Guyana history: Recall from chapter 1 that February 23, 1763, was the day an Akan enslaved man named Cuffy led five thousand in a revolt against his Dutch slave masters on a sugar plantation. This date is commemorated during Guyana's annual Mashramani festivities that take place on February 23, and the fifteen-foot-tall bronze Cuffy monument by the sculptor Philip Moore is one of Guyana's most distinctive landmarks. It was the most successful uprising in the Americas until the Haitian revolution of 1804. Cuffy ruled as governor of Berbice for nearly a year before a Dutch naval fleet was deployed from the Netherlands to regain control of the colony.

One of the first things that Cuffy did after seizing command of a plantation in Berbice was to take the white plantation mistress as his "wife." Cuffy also reenslaved many formerly enslaved African women to work in the sugar plantations during his brief reign.[19] This notion of enslaved men recapturing the manhood deprived them on sugar plantations by conquering white women sexually also shows up in Guyanese fine art. Before the painter Aubrey Williams, a founder of the Caribbean Arts Movement,[20] left to make his career in London, he created the 1960 *Revolt*, which was banned from being exhibited during colonial times, but is now part of the permanent collection in Guyana's Castellani House. In the painting commemorating the 1763 uprising, we see the back view of a shirtless enslaved man. His shackles have been broken. His right arm is raised high with a cutlass (a machete). Scars from lashes lace his back. He faces a white person whose face and hands have been hacked off, as well as a bare-breasted white woman who's just been raped.

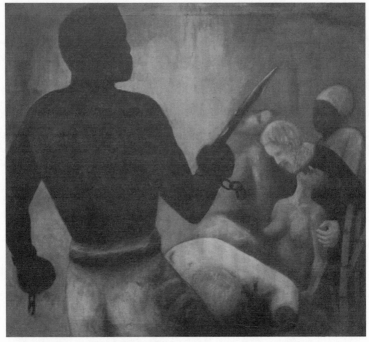

When artist Aubrey Williams's 1960 painting *Revolt* was banned by colonial authorities, PPP leader Janet Jagan was among those that protested. Photo courtesy of the Castellani House.

In the early 1960s, Janet Jagan, the white, American-born wife of the People's Progressive Party co-founder Dr. Cheddi Jagan who would eventually succeed him as president, argued for the right to exhibit the painting. Jagan later made sure the painting was included in the national collection at Castellani House, according to the painter Bernadette Persaud, who served with Jagan on the board of Castellani House. "Why can't Aubrey show the brutality of slavery?" asks Persaud. "Someone has to articulate it. Otherwise you will only get a superficial view of this country. Our parents never talked about what happened at the sugar estates. The women who were trapped and how they survived."

The more successful revolt in Haiti, in 1804, inspired fear of more uprisings in the Americas.[21] In 1807 most European nations banned transport of slaves across the oceans. For enslaved women, this only made heavier their "dual burdens of production and reproduction."[22] It fell to enslaved women to continue laboring as a cog in the machinery of sugar production, but now they were also expected to be the machine producing more cogs. Many enslaved women were desperate. Too sick to work, many female slaves committed suicide, poisoned their owners, or ran away, Woolford notes.[23]

Well before the last sugar plantations ended slavery in Brazil in 1888, sugar planters discovered a new way to replenish the pool of cheap labor: slaves were replaced with large numbers of indentured workers. By the time the Domino Sugar factory was opened, hundreds of thousands of these workers were being sent to sugarcane fields—a lion's share came from India and were shipped directly to Guyana.[24] The five-year contracts were supposed to be more humane and better regulated.

They were, but barely. Bahadur's *Coolie Woman: An Odyssey of Indenture* is a grand telling of the lives of women and the toxic gender dynamics of sugar plantation life and its echoes in modern-day Guyana. There were too many men shipped to the plantations and not enough women, continuing to inflame this struggle over access to women. Indentured women were vulnerable to both jealous Indian partners and men of other races who were sexually interested. This gender imbalance also gave women sexual leverage. They could take new partners, and often did, as Bahadur notes.

Alcohol abuse and rum-shop culture are also part of this legacy. When they arrived from India, ganja, or marijuana, was the preferred medicine of solace for Indians, and they grew their own crops. But the British did everything they could to switch them to rum,

which they produced, controlled, and taxed. Colonial authorities issued rum to indentured recruits as medicine. They imposed heavy license fees to grow ganja. Rum eventually caught on and rum shops popped up, creating a rum-shop culture that endures today, Bahadur writes.

Many indentured women, like the slaves before them, used natural methods of contraception and abortion. Women's reproductive power and control continue to be a source of resentment to men around the world. The anthropologist Brackette F. Williams found these attitudes when she did fieldwork in Guyana in the 1980s.[25] "Men say women start life ahead of men and remain ahead because they are born with an acre of land between their legs"—the ability to have children, Williams writes. On the other hand, men must "buy" land in order to have access to this "feminine acre."

A culture of sexual and general violence endures. This practice of stripping and using belts to lash girl and boy children, as well as domestic and sexual abuse, have endured in my own extended family even after they immigrated from Guyana to North America in the 1970s and 1980s. In 2010, the year Bahadur visited Guyana, at least eighteen women died because of intimate partner violence in Guyana each month—four times the rate in the United States in 2007 and thirteen times the U.K. rate.

The cause of domestic violence continues to be sexual insecurities and jealousy. The method of cutting women down to size has not changed either. Most households in the Guyana countryside still have a cutlass (or a machete). Bahadur writes: "It's the tool to chop cane, and it's still an instrument to dismember women." Farming of bones.

It is this nasty aftertaste that flooded our senses at Kara Walker's Domino Sugar Refinery installation in 2014. The Sugar Sphinx is a

forceful symbol of an exploitative global past that has not passed. In fact, it was being recreated right in front of us as people took selfies that mocked the Sugar Sphinx, sexualized her, and humiliated her. They tried to take her down from her sweet throne.

The Sugar Sphinx is a monument to black women, that mighty mode of production that generated the most valuable commodity of all: unpaid workers who were the collateral that made Empire possible. Walker's installation examined a collective history that remains mostly private: scenes taking place behind closed doors on far-off plantations and in kitchens and sleeping quarters. She made this history and our still troubling reactions to them exuberantly public. Far from gone, the basic carnal impulses that drove her exploitation are never far below the surface.

The same can be said about the basic dynamics around notions of money, power, and luxury. Everything has a price. Two weeks after the exhibit closed to the public, the Sugar Sphinx was dismantled. Walker kept the left hand of the Sphinx as a souvenir. The sugar babies that survived were put up for sale, fetching upwards of $200,000.[26] The Museum of Modern Art was among the collectors. A spinoff exhibit, *African Boy Attendant Curio (Bananas)*, was on view at the Brooklyn Museum in 2015, and then traveled to Miami Beach where he mingled among moneyed collectors at Art Basel.[27]

The rest of the exhibit, including the glorious Sugar Sphinx herself, was bulldozed along with the factory. Thus the material Sugar Sphinx vanished. She is reduced to our memories, an ocean of digital photos, a hashtag. She's an angry ghost—the vengeance of Heaven, called down.

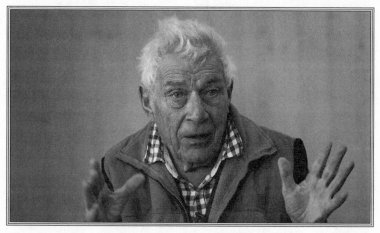

When the British novelist John Berger won the Booker Prize, he used his platform
to expose how the award was funded by exploiting Guyana's land and people.

5

Booker's Prize

In 1972, the British Broadcasting Corporation (BBC) televised the annual Booker Prize for literature's glittering black-tie ceremony. First established in 1969, the award for English writers was modeled after the esteemed Prix Goncourt for French literature. The older prize was established in 1903 and paid French writers in prestige, a boost in book sales, and a token financial award. But the English-language Booker Prize upped the ante: it came with a substantial purse thanks to the generosity of Booker McConnell, a global company based in London that dealt in "sugar, rum and James Bond."[1]

Televising the fancy dinner gave the new prize and the awarded works greater exposure, but as a BBC broadcaster noted, the prize was "nearly derailed" by the 1972 winner for fiction. John Berger, a radical Marxist, art critic, and the author of the novel *G.*, sat for a pre-ceremony interview. His hair was a glossy brown mop and he wore a beige velvet dinner jacket with a butterfly collar.

A BBC interviewer asks: "John Berger, this evening, you will be handed a check for £5,000 as a prize for this book. What are you going to do with the money?"

Berger's response reverberated across the globe:

The prize is given by Bookers, Booker McConnell, who are a firm with extensive trading interest in the Caribbean for 130 years. The extreme poverty is the direct consequence of the exploitation of companies like Bookers and others. And so, I intend, as a revolutionary writer, to share this prize with people in and from the Caribbean, people who are involved in a struggle to resist such exploitation, and eventually to expropriate companies like Booker. I am actually going to give half my prize to the London-based Black Panther movement.[2]

He had a valid point. When Berger announced his intentions, Guyana, the tiny Caribbean country where Booker founded its sugar conglomerate in 1834, had just begun to cast off the chains of imperialism.[3] In a precious ceremony in 1966 London, Queen Elizabeth handed the reins of power to Forbes Linden Sampson Burnham, a Guyanese, British-trained barrister of African descent. The Guiana controlled by the British since 1815 was no more. In its place, the Co-operative Republic of Guyana was born.

But Guyana's economic independence barely had begun. The sponsor of the literary prize, Booker, McConnell & Co., was Guyana's largest employer with a thirty thousand–strong workforce. Guyana produced 45.3 percent of the entire company's operating profits, which included interests in other parts of the Caribbean, Canada, and Central Africa. The company also owned an interest in the royalties from Ian Fleming's James Bond franchise. It was one of many investments aimed to diversify the London-based company's income stream, but none of them come close to the profits drawn from Guyana.[4]

A political and cultural revolution was catching fire across the

globe, with the rise of the Black Power and anticolonial movements in Africa and the Caribbean. But over 130 years in business, Booker had survived far graver challenges than this. The firm survived the end of slavery, the beginning and end of Indian indenture. It fought off a half-century of labor disturbances and British commission inquiries that had come to even blunter conclusions than Berger: they said that Booker and the sugar industry as a whole were suffocating British Guiana's local governance, trapping workers in slave-like living and working conditions, and choking off modern development in British Guiana.[5]

Since the 1920s when Booker McConnell began trading on the London Stock Exchange, it had faithfully delivered dividends to its investors, while Guyana remained one of the poorest countries in the Americas. In 1972, Guyana's gross domestic product per capita was $387.80 in U.S. dollars, compared to Britain's $3,026.41 and the United States' $6,109.69.

At the time of Berger's speech, the Booker, McConnell & Co. firm was riding a historic run-up on food costs that would lead to record-high sugar prices in the 1970s. This gave them ample profits to become a benevolent sponsor of literature. At the literary awards gala, Berger continued to explain the historic and moral dimensions that bolstered his intention to help put his new patron out of business:

> The industrial revolution and the inventions of culture
> which accompanied it and which created modern Europe
> were initially financed by profits from the slave trade. . . .
> The London-based Black Panther movement has arisen
> out of the bones of what Bookers and other companies
> have created in the Caribbean; I want to share this prize

with the Black Panther movement because they resist both as black people and workers the future exploitation of the oppressed. And because, through their Black People's Information Centre, they have links with the struggle in Guyana, the seat of Booker McConnell's wealth, in Trinidad and throughout the Caribbean: the struggle whose aim is to expropriate all such enterprises.

Caribbean historians such as Eric Williams[6] and Guyanese activists such as Dr. Cheddi Jagan[7] had been exposing this rapacious behavior for decades. But Berger brought the story to a much broader audience. When Berger hijacked the Booker stage, this message echoed loudly. The British press largely dismissed him as a "literary thug" and his message as white guilt and Marxist bollocks. But they spread the message nonetheless. Berger's warnings that the Black Power movement would put Booker McConnell out of business proved to be prescient. (As we learned in chapter 2, four years later, Guyanese prime minister Forbes Burnham, while toking a Cuban cigar at the presidential residence at Castellani House, ejected Booker from Guyana and nationalized the sugar industry.)

Guyana had been a rich prize for a bottom-line outfit like Booker, operated by remote control an ocean away. After Empire, though, the country's riches would prove to be a mixed prize for the Guyanese people.

Among the most striking images in the exhibit *Artist & Empire: Facing Britain's Imperial Past*, mounted at the Tate Britain museum in London through 2016, was a series of colonial maps. Maps create worlds. They tell a story of domination from the perspective of the powerful. At the height of the British Empire in 1922, the United

Kingdom controlled nearly a quarter of the world's landmass. A world map created by an English communications company had the British Isle at the center. British-controlled territories were rendered in red. The lone red speck on the continent of South America was British Guiana.

My parents' country always seemed like a random, out-of-context place. Guyana is Caribbean, but it does not touch the Caribbean Sea. It is located in South America, but it is geographically isolated by the rainforest that covers 80 percent of its land. It is sequestered physically and culturally from its Spanish-, French-, Portuguese-, and Dutch-speaking neighbors. Its two largest ethnic groups have roots in two disparate parts of the Empire: India and Africa. With less than a million people, it's one of the most sparsely populated countries in the world.[8]

Why would it even be worth the imperialists' trouble?

For traders like Booker McConnell who controlled shipping and peddled sugar and rum, Guiana provided easy access to global markets via the Atlantic Ocean. Back in Great Britain, keeping an imperial foot planted in Guiana (whose landmass was roughly equivalent to Great Britain) gave the illusion that the global scales were properly balanced and under their control. Maintaining the illusion of world domination helps explain why British Guiana slave owners, planters, and traders became among the most powerful in the Empire.

But off that grid, it is an entirely different story. When the original native indigenous inhabitants lived there, Guyana (Amerindian for "land of many waters") was not a prosperous place—for humans anyway. Lush flora and fauna, jaguars, lemur, red howler monkeys, all manner of animal species thrived in the endless forests. That ecosystem had its own balance. The indigenous Caribs, the Akawois or Waikas, the Arawaks, and the Warrous (or Guaraunos) stuck to

fishing or subsistence farming and moved around a lot. They were enslaved until 1793.

The torrential downpours and scorching equatorial sun, as well as plagues such as malaria and yellow fever, meant that few humans willingly chose to grow deep roots there. The Spanish touched down at the end of the fifteenth century. The British explorer Sir Walter Raleigh famously took two trips to Guiana in the 1600s in search of El Dorado, the mythical city of gold. Sugar began to be cultivated there in 1658, and the Dutch brought African slaves to work the plantations starting in 1640.

The small trickle of settlers from the Netherlands, France, and Spain faced disease and bloody slave uprisings (most frightening to the colonists, the previously mentioned Cuffy uprising of 1763). When the Dutch controlled the territories, they devised seawalls to protect the coastal villages located several feet below sea level. Thousands of African enslaved workers were shipped in to plow 100 million tons of water-logged clay on the coastal land using hand shovels.[9]

For settlers, survival meant triumphing over water, outlasting their European rivals, and, most importantly, constantly replenishing a steady flow of cheap labor. By 1814, the Dutch and French ceded the territories of Berbice, Demerara, and Essequibo to the control of a few British planters. The British Empire consolidated the three colonies into one, formally creating British Guiana in 1831.

In 1815, a twenty-two-year-old man named Josias Booker left the United Kingdom to take a job helping to manage a cotton plantation in British Guiana.[10] After spending nine years working on British Guiana plantations, Booker was encouraged by the possibilities he saw there. The soil was constantly soaked and battered by the rain, which meant that it was not as depleted as that of its neigh-

boring Caribbean islands, which had been aggressively colonized a century earlier. And Guiana's climate allowed it to yield two crops per year, instead of just one.[11]

Josias Booker invited his brothers George, William, and Richard to join him in business.[12] The Booker brothers became among 2,500 whites that inhabited the colony, along with 75,000 slaves and 2,500 free blacks. The brothers established their own ship fleet. They used the boats to take themselves and various products back and forth between a base in Liverpool where they handled shipping, supplies, and distribution.[13] Thanks to the slave trade, Liverpool had been transformed from a sleepy fishing village to a center of international commerce, a boomtown flush with proceeds from human and other chattel.

They incorporated as Booker Brothers & Co. in 1834. At the time Guiana was still known by colonists as the "White Man's Grave." The grave claimed two of Josias Booker's brothers, and several nephews and more than a half-dozen business partners who died of yellow fever and other sudden illnesses.[14] If it was a grave for white men, it was more like a cauldron for African slaves brought there to work. Upwards of 1 in 3 died during passage. From 1821 to 1832 alone, the slave population in British Guiana declined by 52 thousand. Abolitionists pointed out that if this mortality rate were experienced by all the world's peoples, the earth would be depopulated in fifty years. Absentee owners were looking the other way while local management was "systematically working negroes to death in the interest of a high sugar output." Fear of revolts was constant, "holding as we do dominion over negroes by a mere spell," as one British Guiana planter lamented. When they tried to enlist the aid of Amerindians, they weren't much help either. "The garrison of the Indians whom the government subsidized as an additional security force were asleep at their hammocks far up the river."[15]

Over the next century, though, when things fell apart, the Booker brothers and their descendants developed a knack for being at just the right place to vacuum up the pieces. Eventually, Booker became its own vacuum. The first threat to the business came the same year Booker incorporated: Great Britain abolished slavery in 1833. Lucky for the Booker brothers, key members of the British political, clergy, and banking systems also had considerable slave holdings. They often described themselves using euphemisms for slavers such as "West Indian merchants" or "planters and traders" and demanded that the British government compensate them for loss of "property." Parliament approved a pot of £20 million pounds (£16.5 billion in today's currency) to compensate owners for their contributions to the treasury, and for their role in building Empire and enhancing national development.[16]

The actual value of the slave market was placed at £45 million. But Parliament agreed that the slaves themselves would pay the balance by working as free "apprentices" for a period of several years after their owners got paid to free them. So formal emancipation did not come until 1838.[17] For British investors such as the Booker brothers, abolition was a cash bonanza, producing a "feeding frenzy" in London to make claims on the pot.[18] Once-closeted slave traders came out of the woodworks and tied up the courts with claims and counterclaims for their share of the proceeds. Banks, including Barclays, Lloyds, Royal Bank of Scotland, elite families, and at least 128 Anglican members of the clergy in Britain and Ireland who had slave holdings throughout the English-speaking Caribbean cashed in.

In determining how much compensation they would get, the Booker brothers had a formidable advocate in their Parliamentary representative, a Scotsman named John Gladstone, grandfather of a future British prime minister. Gladstone was a Liverpool financier

with investments in seven estates in British Guiana and six in Jamaica. Gladstone and the rest of the London policy makers negotiated a formula for reparations that amounted to £51 per slave in Guiana, compared to Barbados planters who got around £21 per slave.[19]

For a debt-ridden Britain still trying to pay off the £1 billion it racked up during the Napoleonic wars, reparations served as an economic stimulus package. It represented 40 percent of government expenditures in 1834, at a time when the country was £800,000 in debt.[20] It allowed for new investments throughout the British economy. Traders cashed in and invested in the emerging industrial economy, the arts, and education institutions. The slaves themselves got nothing and were set loose in continents where their only means of survival came from their former owners.

This turned out to be good news for Booker Brothers. The Booker brothers and their associates collectively made claims on fifty-two slaves, giving them a cash injection of £2,884, according to newly publicly released archives.[21] The owners got compensation for the slave holdings paid in cash up front. In addition, the enslaved workers were required to continue to work for free as "apprentices" for another four to six years. While many other British Guiana planters used abolition of slavery as an opportunity to liquidate their human assets and get out of the sugar business, the Booker brothers seized the opportunity to buy those sugar plantations cheaply. By August 1, 1838, the Booker brothers' enslaved workforce grew to 315 working in bondage on Plantation Greenfield. After the post-emancipation apprenticeship was complete, the Booker brothers manumitted the slaves, per the new law. "Today I had the privilege of mustering the slaves and giving them the good tidings that they were free, resulting in great rejoicing throughout the plantation," George Booker wrote in a letter to his brother Septimus.[22]

By the mid-1860s, Booker Brothers was part of a planting class that operated 139 sugar estates in Guyana, making British Guiana among the top ten sugar producers in the world. Josias and George Booker both spent many years as elected members of the British Guiana's Court of Policy and among the elite group of planters who dictated local affairs. Planters convinced the British government to help them find replacements for slave labor.

Gladstone, the formidable member of Parliament representing Liverpool, did not reinvest his compensation money in Guiana or Jamaica. (He personally received among the largest payouts given to any individual, £110,000—£78.3 million in 2010 values.) Instead he turned to the next big thing: India. Gladstone invested in ships and transportation infrastructure. The British government eventually helped subsidize the financiers such as Gladstone who would go on to ship 3.5 million Indian workers to the West Indies between 1835 and 1917.

British Guiana was first in line to receive these workers, and by the time the practice ended in 1917, the colony received 240,000 Indian indentured workers.[23] This gave East Indians a numerical majority of Guiana's population that continues today. It also gave birth to an epic grudge match, an obsession with race and its attendant economic, cultural, and political divisions. These conflicts drive virtually every conversation in postcolonial Guyana.

The irony of Berger's 1972 donation to the Black Panther Party of London is that, by that time, very few black workers still worked on Guyanese sugar plantations. The sugar workforce was almost entirely East Indian. Post emancipation and today, African descendants comprised just over a third of Guyana's population, but they have an outsize visibility and presence in Georgetown, the capital city, and in the global imagination for a variety of reasons. Higher visibility for

Afro-Guyanese would eventually pay off politically with imperialists in the United States and Great Britain. After Amerindians, many of whom have continued a subsistence life in traditional villages, the Africans lived in the colony longest. The brutal process of slavery assimilated them to the European power structure and weakened cultural ties to West Africa. (*Obeah* and *kumfa*, two African cultural practices, are two rich exceptions.) Most Africans converted to Christianity and attended the colony's government-sponsored, but Christian church–operated, schools.

After slavery ended in 1838, many black people wanted nothing to do with the sugar industry—although some did move to better jobs in sugar factories. The majority of Africans, such as those on my father's side of my family, formed a majority of the population in the Georgetown capital. A small (often mulatto) elite gained entry-level civil service and corporate posts. When bauxite was discovered in 1910, Africans comprised the majority of that workforce. Many blacks, such as my ancestors on my mother's side—descended from African, indigenous Amerindian, and East Indian groups—struggled to build their own farming communities and did small-scale mining. Despite these relative advantages, both of my parents experienced grinding poverty that inspired them to pursue education and work opportunities in Canada in 1970, shortly after Guyana's independence.

The engine of sugar that dominated Guiana's economy roared on, propelled by Indian workers. But this workforce was initially rendered invisible, tucked away on plantations, where after slavery they were essentially a scab workforce, treated only marginally better than the African slaves before them. Floggings, miles-long commutes, and deplorable housing conditions continued. The fact that Indian migrants retained their names, their culture, religion, and

identity was a source of group esteem (and in some cases a sense of superiority). But this also marginalized them and led to high levels of illiteracy because the earlier groups of Indian migrants could not attend public schools because nearly all were operated by Christian missions and many indentured families refused to abandon their religion.

East Indian workers enjoyed some relative advantages. They were voluntary migrants. Even if under false pretenses, even if they later regretted it, most boarded the ships for a reason and by choice. Because of the investment involved, the planters and authorities tried to make their lives comfortable enough that they would stay and not exercise their right to return to India. Colonial authorities gave them housing and small tracts of land never given to African workers.

Similar race, labor, and migration patterns have been repeated across the globe. The lingering social hierarchies are almost always a function first of white supremacy, and then of when the various ethnic groups arrived and under what terms. Often they produce the same pernicious stereotypes: The unassimilated indigenous Amerindian population (12 percent of Guyana's population) are the most disadvantaged. There is the stereotype of the shiftless, lazy African who didn't want to work. Finally, there are the "industrious" Asians—model minorities. The Europeans who stick around are natural leaders.

Multiculturalism and conversations about race often devolve into a near-constant squabbling over who suffered more and who contributed less. There is rarely a substantive conversation about how everyone got there in the first place, and the global political and economic forces that conspire to keep everyone stuck in place.

From the perspective of Empire, propping up the sugar industry

became both a matter of maintaining that map of global domination and part of the White Man's Burden. The British believed sugar to be a civilizing influence. Without it, all their investments in taming the jungle and creating a society would vanish. The British government guaranteed to buy British Guiana's sugar and negotiated price supports for years at a time. "The state was in fact subsidizing the sugar industry; it was deemed inviolable, the fount of civilization," Clem Seecharan explains in *Sweetening Bitter Sugar*.

Even with the British government's support, sugar remained a volatile business. In 1886, the last of the Booker brothers and their sons retired from the sugar business, as part of a mass exodus from the industry. Between 1885 and 1904, sixty-three plantations disappeared, most of them abandoned. They faced competition from subsidized beet sugar from France and Germany, which helped to drive down prices. After a half-century in business, the Booker family moved on. They passed their holdings over to a partner, McConnell.

The Booker McConnell brand would have several other lives both inside and outside Guyana.[24] The firm continued to pursue its own interests, even if many experts warned that sugar was threatening the future of Guiana as a whole. In 1896, a Royal Commission concluded that the colony was endangered by overdependence on sugar. "I think we shall have to clear away the plantation system," one writer insisted. "It hinders development and though sugar is the most valuable crop these places can produce . . . it is rather too dangerous."[25]

Four decades later, another British investigator was appalled to find the same 1880s equipment being used on Guiana sugar plantations. "The Demerara planters are simply living in the slave tradition," the writer said in 1929. "They organize their estates and factories on the assumption of that abundant labour at no cost and

then blame the labourer's laziness when they don't get it."[26] Even the colonial British Guiana governor Sir Gordon Lethem, who served in the 1940s before being "retired," fretted about the sugar planters' influence: "If we are to sit back and do nothing except where sugar comes into the picture, this place will remain one of the blackest spots of the Empire."[27]

In the 1920s, soon after the end of indenture, Booker McConnell seemed to be making a pivot. The first step was listing the company on the London Stock Exchange. This infusion of investment from British investors helped Booker McConnell begin to diversify its holdings and expand. Booker McConnell eventually established a developing world empire of its own: retail and shipping, as well as sugar and rum operations in Britain, Trinidad, Barbados, Jamaica, Nigeria, Canada, India, Belgium, and East Africa.

Booker also aggressively expanded within British Guiana. After World War II, Booker owned fifteen of the remaining nineteen sugar estates. And just as they took over failed sugar plantations, they took over virtually any other business that failed on the colony. Booker's tentacles went beyond private sugar estates and into virtually every area of life in British Guiana.

Booker McConnell owned and managed real estate. They ran Bookers Stores, primarily retail. They ran taxi companies. They manufactured pharmaceuticals and sold them. (Limacol, a mentholated lime splash labeled "freshness in a bottle," was among their inventions and remains an iconic Caribbean product.) They sold insurance. They were in advertising. They controlled newspapers and radio stations. "Bookers' impact on the economy of the country was so great, that Guyana, then known as the colony of British Guiana, was often acidly referred to as 'Booker's Guiana.'"[28]

Over the centuries, Guyana's basic topography never changed.

There was always too much rain. There were never enough workers to keep back the rain. There were never enough profits to cover the losses caused by the rain. Sugar prices spiked and tanked, keeping planters on the ropes. Instead of investing in modern machinery and methods, or investing in entirely new industries that could sustain the economy, the British Guiana plantocracy—half of them still living an ocean away in Great Britain—just squeezed labor. There was a reform effort led by Jock Campbell, chairman of Bookers from 1934–1966. He attempted to build some worker housing and allowed some native Guianese to rise in the ranks of Booker, but to those who had been toiling for centuries, it was too little, too late.

Eventually, the descendants of the workers who had arrived in Guyana expressly to become a cog in this wheel of production received better educations, traveled, and began to put the pieces together. They were inspired by India's independence in 1947 and Ghana's independence ten years later. They attended Court of Policy meetings. They joined labor unions. They started their own unions that were economically independent of the estate owners. Some of them studied abroad and were exposed to ideas outside the British colonial education system. They ran for public office. And under a new constitution that allowed everyone to vote, they got elected.

Dr. Cheddi Jagan, British Guiana's first elected premier under universal suffrage, emerged as the single most popular political fig-ure. In 1953, he led the People's Progressive Party (PPP) to win eigh-teen of twenty-four seats in Guyana's Parliament. He had studied dentistry in the United States at Howard University and Northwest-ern University, but he had found the United States to be no haven from racism. When he briefly considered staying there, he was told he could not practice dentistry in the United States because he was barred from being a citizen under the Oriental Exclusion Act of the

late 1920s. A bizarre outcome since he was the third generation of his family to be born in South America.[29]

When he returned to British Guiana in the 1940s with his new American bride, Chicago-born Janet Rosenberg, no one was more fired up about the fight against the sugar barons than Cheddi Jagan. Part of his passion may have been that, as a dentist, he was the occupational enemy of sugar. Part of it was a karmic debt paid on behalf of his parents and grandparents who toiled away on Booker plantations with no upward mobility or route to improving their condition. Either way, it was war: "We are going to bury the bitches," Cheddi Jagan said at a rally. "They say sugar doesn't pay. Why the hell they keep planting it?"

In 1953, Jagan published *Bitter Sugar*, a pamphlet that rattled off a laundry list of predatory behavior on the part of "Big Sugar." "The Sugar Gods." "Sugar Imperialists." Among his complaints: Booker did not, nor was it required to, pay into the government's pension scheme. The government invested in irrigation schemes for their large plantations that supported sugar, but not for the small farmers. Booker discouraged its workers from raising their own farm animals or growing other kinds of crops by charging them stiff fees.

That same year, Booker helped convince the government to abolish the three taxes that the industry loathed the most: taxes on distillery (rum), taxes on acreage (land), and the sugar duty.[30] To Jagan, this was unconscionable bit of tax-dodging. It gave the industry license to exploit the land and people and give virtually nothing back to help it develop. Jagan advocated going farther than simply taxing the companies. "The wealth of the sugar industry must be better distributed so that the workers must get their fair and due share," Jagan wrote. "As a socialist party, nationalisation of the sugar industry,

and indeed all major industries is our objective. In the interim, while we are still tied to British imperialism with limited constitutional powers, certain reforms have to be undertaken to break the back of imperialism."[31] Jagan and his People's Progressive Party never got that chance. They spent 133 days in office. On October 9, 1953, British troops arrived to British Guiana and dissolved the constitution, with the following announcement:

> It has been evident that the intrigues of Communists and their associates, some in Ministerial posts, threaten the welfare and good administration of the colony. If these processes were to continue unchecked an attempt might be made by methods which are familiar in some other parts of the world to set up a Communist-dominated state. This would lead to bloodshed. In view of these latest developments, Her Majesty's Government has felt it necessary to send naval and military forces to Georgetown (capital of British Guiana) with the utmost dispatch, in order to preserve peace and the safety of all classes. Any reinforcements that may be necessary will be sent from the United Kingdom.[32]

Troops jailed Jagan, his wife, Janet, and nearly all of the People's Progressive Party leadership. The Afro-Guyanese Forbes Burnham, also a co-founder of the PPP, was tellingly never jailed. Colonial authorities put a ban on socialist books, from the communist classics by Marx and Lenin to local books written by progressive Guyanese writers. Among the banned books was by one Martin Carter, a Guianese writer and PPP activist, titled *Hill of Fire Grows Red*. Published in 1951, it memorialized the Enmore Martyrs, five sugar

workers who were shot dead by police while protesting at one of the Booker sugar estates in 1948.

The British hoped that the red cloud hovering over the tropical country would pass. When that didn't happen, they spent most of the 1950s and 1960s stalling British Guiana's independence. Burnham split from the PPP and started his own party, the People's National Congress (PNC). After Cuba fell to Fidel Castro's 1959 socialist revolution, nationalizing its massive sugar industry, the Americans took a renewed interest in British Guiana.

American president John F. Kennedy summoned Dr. Cheddi Jagan to the White House in October 1961.[33] During the White House tête-à-tête, Jagan made no secret of his socialist beliefs. JFK, still humiliated by the Bay of Pigs fiasco that spring, emerged from the meeting resolved that, democracy or not, Jagan had to go. The young American president vowed that another socialist country would not rise in the Americas on his watch, and he demanded that the British help in this effort.

The United States flooded British Guiana with millions of dollars[34] to sabotage Jagan's leadership.[35] The CIA seeded a Guianese opposition party and trained them in guerrilla tactics. They supported Burnham as he broke from the PPP to form his People's National Congress, which drew away many supporters of African descent. And the CIA helped the PNC instigate racial violence between the two major ethnic groups: Africans and Indians. There were bombings, and stores were burned down. As in plantations in the early colonial era, raping women of other ethnicities became a tool of terror.

My mother remembers the mid-1960s vividly. She was boarding at St. Joseph High School, a convent school in the city. She had to return to her family's simple country home in the Essequibo Coast

The celebrated Guyanese poet Martin Carter's life and work articulated the compromises artists must make to survive. Photo courtesy of Nigel Westmaas.

on the Pomeroon River for six months until the violence simmered down. My mother had medium-dark skin and soft curls, sometimes blown straight. She could pass for either Indian or black. She was in a forbidden love affair with an East Indian boy named Bishnue. She didn't know who might target her for rape or violence. All of this chaos gave the British cover and an excuse to bow to U.S. pressure to delay British Guiana's independence until it devised an election scheme that put their man Burnham in power.

Born just a year after John Berger, in 1927 in Georgetown, Guyana, few artists more clearly voiced the thorny contradictions in the bumpy road after Empire than Martin Carter. Carter fought the British colonial authorities who jailed him, banned his books, and put him on house arrest and unable to read his poetry publicly for years. Carter also spent much of his professional life working for a company called Booker McConnell.

Based on a lifetime of experience as a writer and activist, Carter said that there is no use for "intellectuals" in a place like Guiana. Ideas had to be put to work. In a politics bitterly divided by race, he refused to pick a side. "Your whole attitude was one of bringing about a sort of reconciliation between the races, between the Indian

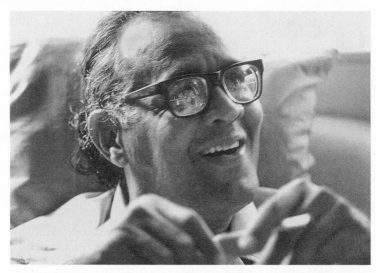

Poet Martin Carter, in his later years. Photo by Errol Brewster, courtesy of Michael Gilkes.

and the Negro," Carter said later. "I thought anything that could bring about a diffusion of tension was worth fighting for, because no one who had not lived out here could have imagined what was going on at the time. Then the very trees almost failed to sprout."[36]

Born among Georgetown's mixed-ethnicity elite that dominated social service (Carter worked for the head of prisons when he was in his twenties), at first he resisted his colonial bosses in secret. Carter wrote for the PPP party organ, *Thunder*, under the pen name M. Black.[37] He wrote poems about life on the sugar estates and the horrors of slavery. He lived close to the Jagans' Georgetown home and was a frequent visitor to the salons and conversation series held there.

In 1953, he resigned from his government job to become a full-time member of the PPP. Following the PPP's victory at the polls, Carter was one of a handful of leaders who was jailed. The British troops rounded him up and put him to work at a work camp

on Atkinson Field, a former U.S. military base, for three months. During his internment, party members smuggled out his collection, *Poems of Resistance*. The main printer for the party was under police guard, so they had it printed at a mental hospital.[38] Later published as *Poems of Resistance from British Guiana*, in 1954, the book was eventually translated into twenty-seven languages and added to the socialist canon.

For years, Carter had despaired over the protracted racial struggle embodied by two leading political rivals: Cheddi Jagan and Forbes Burnham, who were both friends. When Burnham split from the People's Progressive Party to form his own party, Carter stuck with the Jagans. In 1957, when Jagan publicly criticized Carter and other "ultraleft" party members; Carter left Jagan's PPP.

Carter did some school teaching, but struggled to find work. "I think that was a very bad time for him because after moving from that revolutionary, anti-imperialist anti-capitalist period he was unemployed for a time," the noted writer George Lamming later recalled. In the meantime, Carter's writing drew admiration from the unlikeliest of places: the sugar authorities. Booker chairman Jock Campbell was inspired by Carter's poetry of the early 1950s and hired him as information officer for Booker. The father of four reluctantly agreed to take the position. "He was rescued, in an odd kind of way by Bookers—the company that most obviously represented the continuation of that old social order," recalled his friend George Lamming. "I think that he was rather burdened by his predicament of having to do such things in order to support his family."

When Burnham assumed the prime minister's office in 1966, Carter chose to view this as progress. Carter resigned from his job at Booker and was appointed to the Guyana delegation of the United Nations in 1967. A year later, he returned to Guyana to join the PNC

government as minister of information, working for the cultural nationalist Forbes Burnham. "The mood of the chief spokesman [Carter] was very forward looking, with ideas of breaking through to the interior, the pioneer spirit, the cooperative movement, and especially the feeling that they were going to let a thousand flowers bloom," recalled Eusi Kwayana, an Afro-Guyanese writer, educator, and activist who had served in both the PPP and the PNC.[39]

At a groundbreaking 1970 Caribbean writers conference, Jamaican poet Andrew Salkey similarly recalls Carter seeming ebullient: "Looking, for all the world, like a romantic, imagist poet, hopped out of the fire and, now, dead centre in the frying pan. His words were tellingly chosen; his person, a gentle, tall, big man, a poet who may yet do a very serious injury to the sterile vocabulary and syntax of bureaucracy."

Later it would emerge that there were serious tensions and conflicts between Carter and his new boss, Burnham, at the PNC.

An ocean away, the Booker prize–winning John Berger lay between a similar rock and hard place. After Berger's 1972 speech announcing he would donate half of the £5,000 prize to the Black Panthers, the left criticized him for keeping half the prize money for his own art. His critics on the right blasted him for not giving all of the prize money back.[40]

Throughout time or place, these are questions that all artists face. Can an artist ever truly tell the truth to the patron? How does the artist survive?

Soon after the successful Caribbean writers' conference sponsored by the newly independent Co-operative Republic of Guyana, Carter quietly left his post.[41] He returned to his old company, to edit the *Booker News*, a job he would keep through most of the 1970s.[42] Carter made no public announcement that he was leaving the Burn-

ham administration, except a poem he published in the Sunday
newspaper:

And would shout it out differently
if it could be sounded plain;
But a mouth is always muzzled
by the food it eats to live.

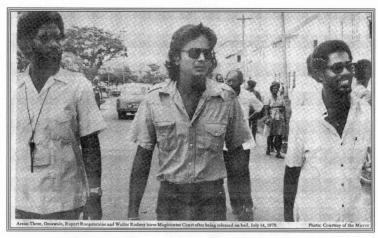
Arson Three, Omowale, Rupert Roopnaraine and Walter Rodney leave Magistrates Court after being released on bail, July 14, 1979. Photo: Courtesy of the Mirror

Dr. Walter Rodney (right), Dr. Rupert Roopnaraine (center), and Dr. Omowale (left) after a hearing for charges that they burned down the Georgetown headquarters for the PNC in 1979. Photo by Nigel Westmaas, Walter Rodney Collection, Atlanta University Center Robert W. Woodruff Library.

6

Bury the Voice

"Walter, what's the position now, in Guyana?"[1]

The British Broadcasting Corporation's *Black Londoners* radio program is live on the air. It's July 13, 1979. Pioneering BBC host Alex Pascall wants to hear the latest from Dr. Walter Rodney, the world-renowned pan-Africanist historian calling in from his native Georgetown, Guyana.

Once again, Rodney's on the ropes. He has just made an appearance at the magistrate's office where he faced charges of burning down the PNC headquarters, along with two other scholar-activists organizing against the current regime. Pro-government supporters crashed the rally outside the court in support of the defendants and badly beat picketers and a *Catholic Standard* photographer.[2] The good news was that Rodney remained free on bail. The bad news was his passport was still frozen, and he was no closer to hearing the evidence against him. "So long as the trial is on, so long as the case is left to hang over our heads, then quite obviously, it means that I would be a prisoner within Guyana," Rodney explains to BBC listeners.

After nearly two decades of study and travel abroad, Rodney had hoped that he and his wife, Patricia's, hometown would be a more

peaceful place to lay their heads. Cold War–era authorities had been keeping tabs on him since his undergraduate days in Jamaica and graduate school days in London in the 1960s,[3] carefully monitoring his student visits to Havana and Leningrad.[4] By age twenty-four, he had earned a PhD in history for his 614-page study of the West African slave trade, and had spent two years teaching in Tanzania.[5] But he earned global notoriety nine months into a teaching job at his undergraduate alma mater, the University of the West Indies. He was away at a black writers' conference in Montreal when the Jamaican government expelled him, fingering him as the ringleader of a "hotbed of Black Power agitation" among university students, Rastafarians, and "known political hoodlums."[6] Rodney's young supporters marched and picketed in the streets in protest. Several lives were lost.[7] There were millions of dollars in property damage in what became known as the 1968 "Rodney Riots."

Rodney spent the rest of his twenties teaching at a university in Tanzania, where he wrote the anticolonial polemic *How Europe Underdeveloped Africa*. "It was all impossibly glamorous, this roving revolutionary who worked in Kingston, London, Dar es Salaam, and Georgetown, the brilliant scholar who wrote his doctoral thesis at age twenty-four, the fiery activist who was the scourge of at least two governments," as one writer later put it.[8] "Rodney was like the James Bond of social theory, an international man of mystery with a PhD and a conscience. He liked his governments shaken and stirred."

With his trademark certainty, Rodney tells the BBC radio host that his Working People's Alliance (WPA) is on the verge of putting an end to Burnham's PNC rule. Sugar, bauxite, and university workers are striking, and public demonstrations are swelling in the streets.[9] The movement has the support of both Guyana's African minority and majority Indian population. They would soon join

their Caribbean and Latin American neighbors who were tossing out corrupt regimes like spoilt milk.

"There is a recognition on the part of the Guyanese people that the time has come to make a tremendous effort to deal with the dictatorship, what one can call the surviving dictatorship in the English-speaking Caribbean," Rodney tells BBC's *Black Londoners* listeners during this 1979 interview. "Because we have had this period of tremendous upsurge in Grenada, in Dominica, in which the Caribbean people have said no to tyranny and to petty dictatorships. And it seems to us that the moment is at hand in Guyana.

"We have reached a point of ultimate confrontation with the minority government led by Forbes Burnham."

Less than a year later, Rodney died in a car explosion. He was thirty-eight.

When do ideas become action? When must the state protect society from subversive ideas? When must society protect subversive ideas from the state?

When George Washington led an army against the British, or the former slave Toussaint L'Ouverture raised arms against the French, were they heroes or scoundrels? Was Fidel Castro a murderous, thieving, power-mad tyrant? Or was he a Cuban visionary who dethroned the wealthy elite and dreamed of an island of equity? These are the kind of questions that time, distance, and perspective help us answer. Walter Rodney (1942–1980) was the historian who had no time to wait. He refused to be muzzled by such questions— or anything else.

Rodney has been dead nearly as long as he lived, but his words and deeds have more power than ever. He is a hero among pan-African intellectuals. His iconic beard, Afro, and spectacles in sil-

houette are an instantly recognizable symbol of ideas in action, culture in defiance. His voice, image, and biography dominated the iconography for a 2015 exhibit entitled *No Colour Bar: Black British Art in Action, 1960–1990* at the Guildhall Art Gallery in London. From 2014 to 2016, his ghost consumed Guyana in a series of hearings, the Walter Rodney Commission of Inquiry, which dragged on over the course of a historic national election. The hearings aimed to give a definitive answer to who was responsible for the young scholar's death—thirty-four years later. The inquiry would eventually conclude that Guyana's president Forbes Burnham and his African-dominated People's National Congress (PNC) knew of the assassination plot and were key conspirators responsible for Rodney's killing.[10] However, the inquiry cost the cash-strapped Guyana government $2 million (USD), and it was deeply compromised by a proxy war over Guyana's bitter, racially charged national election. Key people never testified, allegiances crossed, trampling over the truth. Even after the commission released its conclusions, many mysteries were left unanswered.[11]

This is all the more proof of the folly of trying to kill a conversation. Rodney's legacy speaks to the challenges of putting ideas into action in the ongoing struggle against oppression and imperialism, from the Black Power movement to the global movement to make Black Lives Matter. Rodney was the scholar-revolutionary who believed the very last place ideas should be is locked in the ivory tower; he thought they belonged in the street. He had a way of making complex ideas simple. He wrote his books and speeches with a mass audience in mind. "Walter's scholarship was, in the first instance, really a scholarship about changing the world," according to Dr. Rupert Roopnaraine, the Cambridge- and Cornell-educated literary scholar and WPA comrade who was part of the trio who

stood trial with Rodney for arson.[12] "It was not a scholarship about footnotes, tenure: It was a scholarship about changing the world. That to my mind is its enduring value."

The great postcolonial writer C.L.R. James saw a different lesson. Shortly after the assassination, James spoke mournfully of Rodney, his former mentee who was a regular at the Marxist study groups he led in London. James believed Rodney's tragic and fatal flaw was his failure to fully "study the history of taking power." Had Rodney studied the timing and mechanics involved in the deadly game of revolution, he would have never been sitting in the fateful car after a rendezvous with a man he believed was a deserter of Burnham's army. "*He should never have been there,*" James told an audience at the University of California. "No political leader had any right to be there. Not only should he have never been there, the people around him should have seen to it that he was not in any such position."[13]

In other words, Rodney needed better tactics. If the movement was a body, Rodney should have protected his head.

But Rodney saw no distinction between the head and body. He did not aim to lead, but to engage the people in conversation to help them discover their own answers.[14] There is always more to know, more dimensions to unpack. Ideas can be ammunition. But they can also fill you up and paralyze you under their sheer weight. Pressure has a way of building. Sometimes events don't unfold as quickly or in the direction one would like. Rodney's life unfolded in such a way that he could not live in passive voice, *analyzing* other actors from the appropriate scholarly distance. He was a protagonist, destined to launch ideas into motion.

"Assassins of conversation / they bury the voice," the poet Martin Carter wrote in a tribute shortly after Rodney's death. But sometimes, by burying the voice, the conversation travels farther and

deeper than if the speaker lived. Here, we will follow it from the Guildhall Art Gallery in London, which held an exhibit dominated by Rodney's image, books, and speeches, to the Walter Rodney Commission of Inquiry in Guyana broadcast online throughout the African diaspora from 2014–16. In the global age of terror, and state-sponsored terror against black, brown, and poor people, Rodney was asking brand-new questions.

Verbatim Transcript. October 22, 2014, Walter Rodney Commission of Inquiry, Georgetown, Guyana:[15]

> *Basil Williams, attorney for the People's National Congress:* Jamaica now—that [departure] was forced?

> *Dr. Patricia Rodney, widow of Walter Rodney:* Jamaica was forced.

> *Mr. Williams:* And that was because of what activity?

> *Dr. Rodney:* Because he talked to Rastafarians and he educated working peoples.

> *Mr. Williams:* And that would trouble the Government of Jamaica? Would you say that the Jamaican Government considered that he was inciting them?

> *Dr. Rodney:* That is what they said. If inciting means teaching people about their African history. That is all he did.

> *Mr. Williams:* Are you aware though that both the Shearer Government and the Manley Opposition were ad idem, they were in agreement that he should be declared persona non grata?

More than four decades later, many are challenging the modest, humblest of notions, that "Black Lives Matter." In 1968, it was the

phrase "Black Power" that was a bridge too far. In the United States, majority-black cities were still reeling from riots that followed the assassination of Rev. Dr. Martin Luther King Jr. on April 4 of that year. U.S. president Richard Nixon ordered a report on "Black Radicalism in the Caribbean." "US diplomats not only closely monitored black power activities in Jamaica and elsewhere in the Caribbean, but they also worked in concert with governments in the region to rein in black power movements and militants and to quarantine the ideological contagion."[16]

Walter Rodney, Stokely Carmichael, and C.L.R. James gave speeches at the Congress of Black Writers, a conference at Montreal's McGill University in October 1968. The writers and activists made no secret of intending to ride the wave of anti-imperial uprisings in India, Africa, and the United States.

On October 17, 1968, sprinters John Carlos and Tommie Smith were suspended from the American team for celebrating their Olympic victory in Mexico City by raising their fists in a Black Power salute. The same evening, a session of Jamaica's Honourable House of Representatives began to address what became known as the "Walter Rodney Affair." The proceedings got off to a fiery start when a member of the opposition party snatched the "mace," a golden staff that was a traditional European symbol of Parliamentary authority, off its place on the House floor, and then stormed off to protest Rodney's treatment by his colleagues. "I am protesting because I think this is intellectual murder!" cried Maxwell Sylvester Carey, a representative of Westmoreland.[17] Appalled members swiftly addressed the grave breach in decorum by voting to suspend Carey and throw him out.

That bit of business aside, Prime Minister Hugh Shearer got to the task at hand: presenting the evidence as to why the House should

join his administration in declaring then-twenty-six-year-old Dr.
Walter Rodney *persona non grata*, justifying its preemptive strike
against him two days prior. Jamaican authorities stopped Rodney's
plane on the tarmac upon his return from a speech at the Black
Writers' Congress in Montreal.[18] Officials informed the pilot that
Rodney, lecturer in African History at the University of the West
Indies, had been expelled and ordered him returned to Canada.

Shearer, Jamaica's third prime minister and a black man,[19]
explained to Parliament members that Rodney had to be banned
because he "had been classified a grave security risk and he was car-
rying on activities which constituted a danger to the security of the
Nation." Shearer presented findings from police files that stretched
back to when Rodney was an undergraduate student. Special agents
had tracked him since he was teenager taking trips to Russia and
Cuba, and when he tried to instigate strikes among the university's
cleaning staff.[20] Even back then, Rodney had refused to bend. He
fired off an essay in the student newsletter in protest of the officials
who briefly confiscated his copy of Che Guevara's *Guerrilla Warfare*,
acquired while visiting Cuba shortly after their revolution. Before
banning him, Shearer told House members that Rodney had been
consorting with Rastafarians, "the unemployed," "half-literates,"
and "known political hoodlums" for "avowed revolutionary pur-
poses," including training in violence and guns.

"When asked what the definition of 'Black Power' [is] and I quote
him—'Castro revolution,'" Shearer continued. "No wonder at a
meeting, a Rastafarian asked, and here I quote: 'We have the brawn,
you have the brains, all we need are the guns.'"

"Revolution must come," Shearer claimed Rodney told students
in a meeting on the Mona campus. "We must be prepared to see it
through. We must stop talking and indulging in academic exercises

and act. Who will be the first to come with me downtown and take up a machine gun?"

The House Leader applauded the government's preemptive action. "I have never come across a man who offers a greater threat to the security of this land than does Walter Rodney," said cabinet member Roy Ambrose McNeil.[21] Parliament members erupted into sustained applause.

This official government narrative was dutifully and unskeptically relayed in the *Jamaica Gleaner*, along with details about the explosive reaction to Rodney's ban: more than nine hundred university students voted to march to the government offices in protest. Other Rodney supporters in the community, including a heavy Rastafarian contingent that grew to thousands, soon joined the students.[22] Protestors were appalled when a tear gas can reached the feet of Rodney's pregnant wife, Patricia, who remained in Jamaica with their nearly three-year-old son. Things quickly gained momentum as different factions of Jamaican society joined in to air their grievances. Buses were upended. Businesses were looted. As least four people lost their lives.

A *Gleaner* editorial urged the government to spend "more and more money to buy information for the state's protection . . . more and more money to recruit, train, and arm the brave personnel who guard the ramparts of secret information . . . so as to forewarn the country of hostile plans of iniquity and revolt."[23] To Shearer, the riots that followed the ban proved that the government made the right call to act before the island erupted. The riot was not a reaction to government provocation, but rather it was a preemptive strike against "terror and destruction" by young people and Rastas "indoctrinated" by Rodney, "he, a foreigner [who] has been plotting against Jamaica."[24]

Much like the election of U.S. president Barack Obama decades later, the election of Prime Minister Hugh Shearer to the newly independent Jamaica would appear to be living proof that Black Power had prevailed. To Rodney, his banning was proof that this was not the case. Back in Canada, separated from his wife, Pat, and young son,

A member of Jamaican Parliament snatched the ceremonial golden staff and declared Rodney's banning "intellectual murder!" Photo by the *Jamaica Gleaner* © The Gleaner Company (Media).

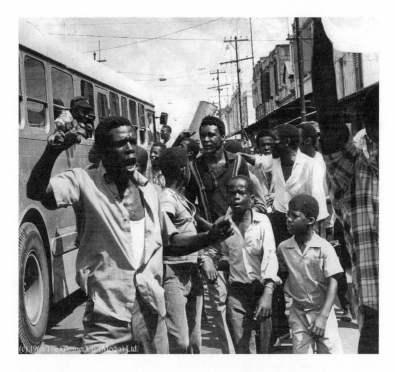

Jamaican university students were joined by a Rastafarian contingent that grew to thousands protesting Rodney's banning from the island. Photo courtesy of the *Jamaica Gleaner* © The Gleaner Company (Media).

who were left behind in Jamaica, Rodney fired back in a letter—later published in the book *Groundings with My Brothers*—brimming with righteous indignation. If the Jamaican government thought Rodney would be chastened by the expulsion from the island in 1968, or the lives lost in its wake, they were wrong.

"The Government of Jamaica, which is [Marcus] Garvey's homeland, has seen it fit to ban me, a Guyanese, a black man, and an African. But this is not very surprising because though the composition of that Government—of its Prime Minister, the Head of State and several leading personalities—though that composition happens to

be predominantly black, as the Brothers at home say, they are all white-hearted."

Later, he wrote: "People like this man here, the so-called, the Dishonourable H.L. Shearer, Prime Minster of Jamaica, this traitor to the Black Race, has no moral authority to lay accusations against me."

As Rodney had been saying in talks given all over the island, while Jamaica had broken free of the British Empire in 1964, it had not eradicated white supremacy. He asserted that vestiges of colonialism were evident in police brutality and murders, special social and economic privileges awarded to non-black and light-skinned Jamaicans, black self-hate and negative stereotyping of Africa. Black Power was also about economic justice and opportunity in societies created solely for the purpose of European capitalism, explained Rodney biographer Rupert Lewis. Lewis was a University of the West Indies student when he accompanied Rodney on trips to poorer rural parts of Jamaica where many Rastafarians lived.

What further inflamed the government was the fact that Rodney had aligned himself with people who were seen as the dregs of society. Before Bob Marley redefined their image as radical-chic, socially conscious stoners, Rastafarians were derided as deviants, parasites, and a cult.[25] They carried on the tradition of Maroons, people who resisted slavery by escaping into Jamaica's interior mountains where they formed communities that retained much of their African heritage and culture. Jamaican police often arrested and taunted them by cutting off locks of their long hair, which some grew into thick, matted ropes inspired by Kenyan Mau Mau fighters. Rastafarianism aimed to "delegitimize the colonial system and critique the continuation of that system in the period after political independence. In designating the colonial system and modern capitalism as 'Babylon'

Rastafari offered an anti-systemic critique of modern capitalism and developed its own type of postcolonial thought," Lewis writes.[26]

As a scholar of Africa, Rodney greatly admired the Rastas' reverence for the continent and their fierce anti-imperial stance. Rodney worked hard to court this community and found inspiration in "groundings," or conversing with Rastas, a movement that he noted, with great clairvoyance, given that Bob Marley was among them, was producing some of the best artists he had seen. "You get humility, because look who you are learning from," Rodney later explained.[27] "The system says they have nothing, they are illiterates, they are the dark people of Jamaica."

The local campus-based Black Power network helped organize Rodney's talks, also known as "reasonings" or "groundings" in the Rastafarian lingo, in poor communities in rural areas and neighborhoods in Kingston. In 1967—a year before Rodney returned to the University of the West Indies—a Black Power branch was set up on the Mona campus. There was no single leader; the movement was "broad and amorphous, not coalescing around any one group or individual," Lewis noted. Among the demands were: to create awareness of what it means to be black; mobilize and unify black people to act in their own interest; reject white imperialism; and seek to ensure the rule of blacks in a black society. The Rastas were also hungry to learn of Rodney's research on Africa and the slave trade and his connections to liberation movements in Tanzania. Sometimes Rodney listened, and at other times he gave talks.

Rodney's notions of Black Power also extended to his definition of what it meant to be educated. The focus, he insisted, should not solely be on knowledge systems centered in Western Europe. Rodney himself had mastered these systems, studying in Portuguese- and Spanish-language archives. But he chose to honor prior knowledge

systems from around the world. Rodney believed the duty of the black intellectual and academic was to "attach himself to the activity of the black masses."

"I lectured at the University, outside of the classroom that is," Rodney explained in *Groundings*. "I had public lectures, I talked about Black Power and then I left there, I went from the campus. I was prepared to go anywhere that any group of Black people were prepared to talk and listen. Because, that is Black Power. That is one of the elements, a sitting down together to reason, to 'ground' as the Brothers say. We have to 'ground together.'"

Rodney demurred on the charges that he crossed the line to actual violence: "You know, it is like that trick question: a man comes up and ask you, have you stopped beating your wife; he makes the assumption that you are beating your wife, and asks you have [you] stopped. It is that sort of nonsense, they throw out a little thing and then get you to grab the bait; and there is another reason I would not defend myself against this."

Rodney did not deny it either. Instead, he packed up his family and returned to his old university job in Tanzania.

Verbatim Transcript. Walter Rodney Commission of Inquiry.

Tuesday, October 22, 2014

Mr. Williams, attorney for the People's National Congress (PNC): Now, Tanzania, from reading your statement it appears that your friends were being arrested.

Dr. Patricia Rodney: Yes.

Mr. Williams: And for serious offences—treason, etcetera—and

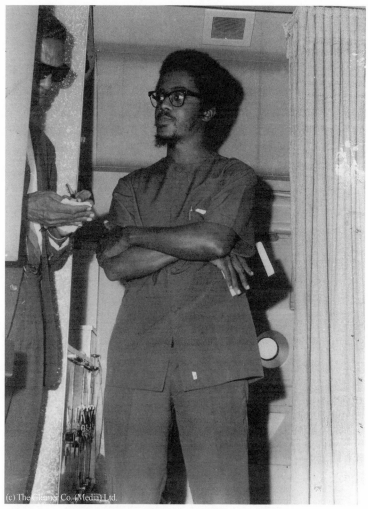

Rodney's 1968 banning drew headlines around the world. Photo courtesy of the *Jamaica Gleaner* © The Gleaner Company (Media).

perhaps . . . was your husband . . . Did he contemplate that he could have also have been arrested accordingly?

Dr. Patricia Rodney: No.

Mr. Williams: When he decided to leave Tanzania would you say he left voluntarily or he was forced?

Dr. Patricia Rodney: Voluntarily and I can find proof. I have an article where Tanzanians said we left because he was offered a different position in Guyana.[28] We left on our own. Nobody asked us to leave.

After leaving Jamaica, Rodney returned to the faculty of the University of Dar es Salaam in Tanzania. Like the University of the West Indies, it was a new university established in the early 1960s as an affiliate of the University of London system where Rodney had earned his PhD. While the British continued their global retreat, they established these universities around the former Empire. As white faculty members were replaced with some black ones, debates ensued over how to resist European values and knowledge systems, and reinvent educational scholarship and institutions.

During these years, Rodney wrote his most iconic book, *How Europe Underdeveloped Africa*. Like Frantz Fanon in Algeria, Steve Biko in South Africa, and Guinea's Amílcar Cabral, Rodney came to be "celebrated for [his] rare ability to do both—pick up arms and intellectually articulate the nature of the African identity," as the writer Nanjala Nyabola notes.[29] She continues: "If colonizers had made Africans into a singular black block of otherness, Pan-Africanism turned this negation on its head, producing a principle of solidarity in its place." For all their achievements, this kind of scholar activism had its own romantic and gender-blind spots, "Man Africanism," in Nyabola's clever framing. There was an emphasis of militarization of the pan-Africanist movement, and little attention to ongoing battles in the private sphere of home and family.

Rodney's *How Europe Underdeveloped Africa* not only inspired

revolutionary action, it also was a stunning independent publishing success story: a global bestseller published by a string of black-owned publishers in a triangle trade among black presses in Africa, Europe, and America. Rodney demonstrated how the same path used to ship enslaved people and products could be a conduit for revolutionary new ideas. It was first published in 1972 in Dar es Salaam by Tanzania Publishing House and in London where a Guyanese couple, Eric and Jessica Huntley, ran the Bogle-L'Ouverture Press. It eventually got into the hands of W. Paul Coates, a director of the Maryland Black Panther Party and a reference librarian at Howard University. "We had begun getting books out of East Africa," Coates recalls. Some had been coming to Washington, D.C.'s Drum & Spear bookstore. "I was the bookseller at the time, and they were always in demand—no matter how many books came in. That in itself was revolutionary because [Tanzanian freedom fighter turned post-colonial leader Julius] Nyerere was in power. It had the flavor of the revolution and challenging the existing press."

Rodney's *How Europe Underdeveloped Africa* was notable for its direct language and accessibility to everyday people who were drawn to what Coates calls Rodney's "scholar/warrior" image. Howard University Press decided to re-issue the book in the United States in 1974. "They presented a more polished version of the book, and elevated it and made it available in hardcover. The book went on to be Howard's bestseller. It stayed a bestseller for many years."

In the book, Rodney applied the Latin American "dependency" theory to the vast history of Africa. It is a powerful and gleeful rebuff of his European training. He took the tradition of stoic, supposedly objective British empiricism he was trained in and mastered, and threw a Molotov cocktail at it. The tone is breezy, confident, full of swagger, and brimming with energy and life. The British historian

George Shepperson's review of Rodney's earlier work applies to both the writer and his approach to writing history: "Historians have beliefs as much as other people. But they are too prone, perhaps, to cram their credos under narrow decks of 'objectivity' in the hope, conscious or unconscious, that the directions in which they are sailing will escape notice. Dr Walter Rodney, however, is not afraid to nail his colours to the mast."[30]

In Rodney's letter to his London publisher, Bogle-L'Ouverture, about *How Europe Underdeveloped Africa*, he preemptively waved away any potential criticism of his lack of footnotes as more bourgeois posturing. It was common among black nationalist historians to skip footnotes, and Rodney provided precious few citations in his manuscript.[31] "I will have to be the authority for whether a given fact, date, name etc. is correct," he wrote.[32] The lack of geographic specificity can be frustrating to the contemporary reader. Rodney erects a mythological pedestal upon which precolonial African woman supposedly stood, and papers over the diversity and nuances of the colonial histories throughout Africa. Rodney did not call Africa a "country" but, in his analysis, he comes dangerously close. And his dogmatic Marxism often flattens what in reality is a textured picture of a vast, geographically diverse continent with fifty-four countries and thousands of languages.

Some may long to trace the trail of sources he amassed. But you can't deny the Middle Finger of it—or the essential truth it conveys: European nations violently carved up Africa, rearranged the existing economic and cultural systems they found there, and created a market dependent on products largely pulled from Africa's own natural resources. This is akin to stealing a fruit tree by armed robbery, and then turning around and demanding exorbitant rates for bottled juice. When, for centuries, prevailing notions of truth

are tilted so hard in a certain direction—toward blaming the con-
quered for their oppression—it is exactly the kind of corrective that
is needed. When European expertise is so uncritically accepted and
so brutally skewed toward a belief in the inferiority of Africans and
their knowledge systems, an overreach in the other direction is nec-
essary, and Rodney stretched to tell an important larger truth. But
when Rodney tackles the then-recent past, the period after World
War II, he provides more specific details, and his analysis comes to
stand on firm and irrefutable ground. This is the era when European
governments backed away from the colonial project, and Rodney
offers compelling evidence that details how private business inter-
ests quickly stepped in to seize the reins of these supposedly post-
colonial societies. *How Europe Underdeveloped Africa* remains an
incendiary work because its basic analysis of systemic, structural
economic global apartheid continues to ring true.

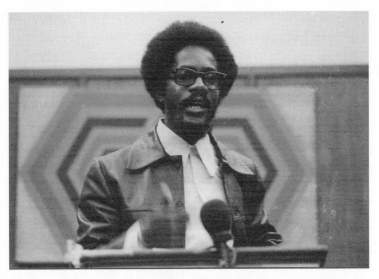

Walter Rodney speaking at Yale University in 1972. Photo by Jim Alexander.
Walter Rodney Collection, Atlanta University Center, Robert W. Woodruff Library.

Rodney and his family spent several happy years in Tanzania, dueling publicly with other scholars and local powers about the best way to restructure that country's postcolonial society. He created a graduate program, continued to rewrite African history, and supported student uprisings and his own growing family. By the mid-1970s, home was pulling him.[33]

So, when he received a letter confirming his appointment to the newly reformed University of Guyana, he quickly made plans to return home, where his parents as well as his wife's still lived. Unlike the universities in Tanzania and Jamaica, the University of Guyana was completely independent of London. For better and worse, Guyana stood on its own.

> Walter Rodney comes from Tanzania in Africa [in 1974]. This young brother who has fought with the oppressed in every country that he has lived . . . In his quiet way, without ringing a bell, he slipped into the Working People's Alliance. He began to teach publicly, in the open air. He began to inspire us with the dangerous air of self-empowerment, self-emancipation, community empowerment.
>
> —*Eusi Kwayana, PPP, PNC, and*
> *WPA leader and historian*

The first thing Walter Rodney learned when he arrived in Georgetown in 1974 to claim a position in his native country was that there were few areas of society that were not under the control of the state. The Co-operative Republic of Guyana now controlled 80 percent of the economy, including the sugar industry and the fledgling uni-

versity established in 1963. In theory, Rodney, the Marxist scholar, was pleased. In practice, that meant that he would have to answer to Guyana's PNC leader, Forbes Burnham, the Afro-Guyanese, London-trained barrister with a knack for maintaining important friendships around the world.

From the moment the Rodney family landed in Guyana, it was clear that the Comrade Leader was not keen to allow a young upstart to outshine him on his own stage—especially one that the United States had been tracking as part of its dossier on Black Power in the Caribbean. Burnham had held power since the 1960s by making odd bedfellows in Washington, Moscow, Havana, and London. As the former British Guiana was granted independence from Great Britain, President John F. Kennedy and the CIA helped Burnham wrestle power away from his more popular rival. As visiting writer V.S. Naipaul wrote of Burnham's voice: "He is utterly calm, and his fine voice is so nicely modulated that the listener never tires or ceases to listen."[34] The Guyanese president sweet-talked everyone from British prime minister Margaret Thatcher to Her Majesty the Queen herself, with whom he boldly flirted even as she handed him the reins of power to his country.[35]

President Burnham maintained power over the overwhelmingly Indian majority population, thanks to international support, rigged elections—and an iron fist. From the moment the Rodney family returned to Guyana in the mid-1970s, Burnham endeavored to make their stay in the country as inhospitable as possible, and he used the many arms of the socialist "cooperative republic" state to do it. Rodney's job offer to chair the history department at the University of Guyana was rescinded. He was blacklisted from securing even a high school teaching job, so he mostly supported his family

by giving lectures abroad. Increasingly Rodney was spending his time volunteering for the Working People's Alliance, a party that was drawing bigger and bigger crowds to antigovernment rallies.

The more support Rodney earned, the more Burnham dug in. Police waged warfare on the Rodney family through weekly weapons searches of their home. Playdates and piano lessons for the three children were sabotaged. Officials even blocked Rodney from dropping off his daughter's birthday treats at the selective government school where President Burnham's children were also enrolled.[36]

Rodney had convinced Dr. Rupert Roopnaraine, the Indo-Guyanese literary scholar trained at Cambridge and Cornell Universities, to return to Guyana to help build their country. He also was part of a small core of Marxist Guyanese intellectuals that challenged the legitimacy of Burnham's rule, encouraged labor demonstrations, and advocated for a multicultural government. One photo from a newspaper clipping from that time period stands out (see page 106). It was taken the same day Walter Rodney called in to the BBC radio host in 1979: Coming from their hearing about arson charges, Rodney is at right, smiling. Omowale, another PhD, looks ahead with gravity. Roopnaraine, captured mid-stride, looks glamorous and steely cool behind sunglasses.

The full story behind this photo is rarely told.

When Rodney called British announcer Alex Pascall at the BBC about his court appearance, he believed that the movement and uprising against Burnham was imminent. After all his study of revolution, seeing it in Cuba, and more recently in Suriname, Grenada, and Dominica, he thought Guyana was poised to catch the wave. A week after his BBC interview, Rodney was on a street corner, ratcheting up the rhetorical attacks in a public rally for WPA

supporters.[37] Since he spoke to Pascall, he learned that Father Bernard Darke, a British priest, had died in a stabbing at the antigovernment demonstration in support of Rodney and the other arson defendants.[38] "Father Darke fell as the first martyr of the present stage of the Guyanese revolution," Rodney thundered. Rodney's stump speech at times sounded more like a standup comedy routine in which President Burnham was the target of a series of rhetorical slaps: "If there ever was such a thing called the Midas touch, which was the touch that made everything turn into gold, then we will have a new creation in this society—the Burnham touch where everything he touches turns to shit," Rodney said, and the crowd howled with laughter.[39]

Rodney fretted about the embarrassment Burnham caused by letting the cult leader Jim Jones set up a compound in the Guyanese interior, which led to nine hundred deaths in a mass suicide in 1978.[40] This, too, had a mark of the "Burnham touch" and embarrassed Guyanese around the world. Foreigners would ask Guyanese people: "'Tell us something about Jonestown. I know you are from Guyana.' And the [Guyanese] person would explain, 'No, you get it wrong. Is Ghana. You get it wrong!'"

Rodney mocked Burnham's plan to build a lavish presidential palace at Castellani House. "King Kong has decided he wanted to build a palace to his ego and a monument to his own stupidity so that he could sit inside and be a monument inside a moment." Rodney suggested the presidential residence should be combined with the zoo next door instead. "People would come from all over the world and pay money to see King Kong."

When the laughter subsided, Rodney told the crowd that they had to make a change. "It is not that they must hold another election and rig it all up. We finish with all of that. They must go!" There was

loud applause. "The PNC must go! And they must go by any means necessary!"

Within weeks, Burnham's voice boomed across government-run radio airwaves, firing shots at Rodney and his Working People's Alliance with poetic flourish. At a speech at the Third Biennial Congress of the People's National Congress in August 1979, he mocked Rodney's WPA party as the "Worst Possible Alternative." He vowed that his ruling PNC party would rise to the WPA challenge: "Our steel will match their steel." And he gave advice to those who sympathized with the WPA, using an allusion to a Lord Tennyson poem on mortality:[41]

Let there be no weeping at the bar.
No quarter must be asked.
None will be given.
And they must make their wills.[42]

Burnham introduced his own nickname for Rodney: "The High Jumper." As a former track star, Rodney had excelled in that event; high speed and agility helped him clear bar after bar. Rodney had to literally high jump to get away from government supporters breaking up his WPA meetings. He dashed all over the country, sometimes wearing a plumber's uniform as a disguise. Pro-Burnham muscle chased Rodney deep into the countryside, where he survived by hurdling sugarcane stalks and eating them for sustenance.[43] That year's annual Mashramani parade, the winning entry in the government-sponsored steel band competition was a song by the police department's steel band that kept getting radio airplay.[44] The title was "Run, Rodney, Run."

The battle continued across the Atlantic Ocean in Africa in May 1980, where Burnham was furious to learn that Rodney had cleared one final bar: he evaded Guyanese immigration authorities by using

an escape route through Suriname to Tanzania, and managed to board a plane to attend the ceremony to celebrate Zimbabwe's new leader, Robert Mugabe, who had finally overthrown white supremacist rule. Rodney was received like a prince as he mulled an offer from Mugabe to write the history of Zimbabwe. Rodney appealed to Mugabe in his battle against Burnham and asked several people there to help him gather arms, according to Lewis. Burnham, also vying for recognition on the world stage, was furious.[45]

Days after his return to Georgetown, on the evening of Friday, June 13, 1980, Walter Rodney met with a man he believed had deserted the Guyana army. As the story has been told, the former military officer had agreed to make him a walkie-talkie device. When Rodney and his brother followed the man's instructions to drive near a Georgetown jail to take the device out for testing, it exploded, killing Rodney instantly.

Rodney's wife, Patricia, awoke the next morning to find a copy of a pamphlet littering the streets of Georgetown:

> *To Walter,*
> *Hickory Dickory Doc,*
> *Appointment at 8 o'clock.*
> *We would not need no bail*
> *when we done with the jail,*
> *and this walkie-talkie start talk.*
> *Rock-a-bye Rodney now lives in the past,*
> *dispatched to his master so quick and so fast*
> *It was never the intention*
> *that his fiendish invention*
> *would choose his own lap for the blast.*[46]

When the Walter Rodney Commission of Inquiry finally released its report in February 2016, after two years and hundreds of hours of witness testimony, this was the narrative delivered in its 134-page report. But one voice was conspicuously missing from the inquiry, someone who could have given better insights into exactly what happened: Indo-Guyanese writer Dr. Rupert Roopnaraine.

Roopnaraine is among the last of the surviving Working People's Alliance members living in Guyana. At the time the Indian-dominated Progressive People's Party launched the inquiry, many people believed it was an exercise meant to scare voters away from the new multiracial coalition of political parties called A Partnership for National Unity (APNU), the multiracial party discussed in chapters 1, 2, and 3. Roopnaraine had joined the coalition that included his former nemesis, the People's National Congress (PNC), which was campaigning to end twenty-three years of corrupt PPP rule in Guyana. This effort to overthrow the PPP was gaining steam when the Walter Rodney inquiry was launched in 2014.

The hearings, and the ghosts of Rodney and Burnham, were a way for the PPP to change the subject away from its own abuses of power over the previous twenty-three years. Roopnaraine had been forthcoming in previous interviews about the WPA during Rodney's final days, in which he painted a much different picture. But he never testified at the Walter Rodney Commission of Inquiry, and his previous statements were barely referenced during the hearings.

In an interview published in 2012, Roopnaraine told the filmmaker Clairmont Chung that at the time of Rodney's death, the WPA was amassing weapons. "It was no secret," he said. In 2009, Roopnaraine was keeping a low profile as a University of Guyana

English professor when he gave an interview with the British travel writer John Gimlette. They sat down in a Georgetown hotel and restaurant, the Cara Lodge, for an interview for Gimlette's well-regarded travel book *Wild Coast*.[47] The two men chain-smoked cigarettes and downed shots of rum. When I reached Gimlette in London in 2016, he told me he had confirmed the following details and quotes from Roopnaraine while fact-checking the book before publication.

Roopnaraine said the WPA had been stockpiling their weapons cache right there, where they sat for the interview, at the Cara Lodge. During colonial times, Forbes Burnham and Cheddi Jagan gathered at the same hotel to plot against British authorities. In the late 1970s, Roopnaraine said a small cell of WPA activists had been setting fire to sugarcane fields controlled by the PNC. "Fire terrorized Burnham," Roopnaraine told Gimlette. "And he started to lose his edge. That July, we burned down the PNC's headquarters and the Ministry of National Development, and then, a few days later, we were all arrested."

So the WPA was in fact behind the arsons. On that tragic day of June 13, 1980, Roopnaraine confirmed that Rodney was seeking to get a line on more military equipment. Rodney and his brother arranged to meet with a man they believed to be a deserter in the Guyana army.

"So the bomb was yours?" Gimlette asks Roopnaraine.

"Yes, yes it was," Roopnaraine said. Rodney's death was actually a "fuck-up." "There was no explosive in the device. It was simply a wooden box with an electronic receiver. The activity was intended as a loyalty test for [the Guyanese Army veteran] Smith, who, it later emerged, had a background in electronics. It turns out he was an agent and that he had loaded the device with explosives."

The agent was working for Burnham after all. "Next thing we know, BOOM! Walter is dead," Roopnaraine said.

The WPA arranged to have a doctor fix up Rodney's brother. WPA leaders came up with the walkie-talkie story to send to the press. And that press release is the story that has been told ever since.

Today, there are two Walter Rodney Courts in England. Several universities in Europe have renamed walks, circles, and squares after Walter Rodney. His papers are held at Atlanta University Center, Robert W. Woodruff Library, where his family preserves his legacy

Rodney's legacy was celebrated during *No Colour Bar: Black British Art in Action, 1960–1990*, an exhibit at London's Guildhall Art Gallery in 2015.

As part of the *No Colour Bar* exhibit, curator Michael McMillan created a replica of the London bookstore that was named in honor of the late Walter Rodney.

through the Walter Rodney Foundation. There are Rodney Symposiums, a Walter Rodney Day at Atlanta University. Every few years there is a conference reconsidering *How Europe Underdeveloped Africa*. In Togo there is a bust of Rodney. His books are translated into several languages.

W. Paul Coates, of the Baltimore-based Black Classic Press, has been Rodney's U.S. publisher since 2011, when he acquired U.S. rights to *How Europe Underdeveloped Africa* from Howard University Press. Coates says it remains one of his bestselling titles. "The prospect of the book still excites people," Coates says. "The legendary sacrifice of Walter Rodney is still talked about. People still remember it, and it has become part of the book now." And in Georgetown, activists Vidyaratha Kissoon and Sherlina Nageer created a series of street-corner conversations called "Groundings,"

Paul Coates, founder of Black Classic Press, Rodney's current publisher. The enduring resonance of *How Europe Underdeveloped Africa* shows how subversive ideas can travel the same global path once used to transport enslaved workers.

launched in commemoration of Rodney's death, on June 13, 2014. They put up a bright sign that read: "GROUNDINGS: Come read and reason!" The official Commission of Inquiry hearings, "one of

our ugly political footballs," as Kissoon describes them, are far from
sight. They played snippets of Rodney's speeches, and brought out
the children's books that Rodney wrote featuring Kofi Baadu and
Lakshmi, African and Indian children's characters set in Guyana.
They have made the "groundings" part of their practice in years
since. "Is nah just to give away de books," as Kissoon wrote on his
blog. At some sessions, they handed out Martin Carter poems.
Other sessions have covered: "Revolutionary love (on justice),"
"Walter Rodney and tolerating (gays) and other people," "reading
as love-making," and "teenage drinking, prostate checks and eating
well."

Rodney's legacy was front and center on December 2015, when my
mother, Serena, my cousin the Rev. Mother Roxanne F. Hunte, and
I walked into the Guildhall Gallery of Art in London. The gallery
has been transformed into a replica of the Walter Rodney Bookshop,
so rebranded in 1981 to honor the fallen intellectual. The bookstore's
Guyanese owners, Jessica and Eric Huntley, were legendary literary
activists who operated the London bookstore and publishing com-
pany Bogle-L'Ouverture Publishing, which also published Rodney's
books.

As we walked through the gallery, we could hear Rodney's voice.
His 1979 BBC radio interview with Alex Pascall was looped on
repeat, so we could hear him trash-talking Burnham and predict-
ing his demise. Rodney's image and likeness were all over the gal-
lery, including the exhibit poster with his iconic silhouette—goatee,
glasses, and Afro. There were early drafts of manuscripts and corre-
spondence about the books they published together. There were post-
ers and slogans and photos of protests about Rodney's assassination.

A group of about a dozen British black children were gathered
around Dr. Michael McMillan, curator of the exhibit *No Colour*

Bar: Black British Art in Action. It was the exhibit's Family Day, and McMillan was explaining the artifacts from the 1970s, and why he had selected them. McMillan, who has roots in St. Vincent and whose long locks were pulled back in a ponytail, pointed to a poster that was one of the first printed of a Rastafarian person in London. He explained that Rastas came from Jamaica originally. In the 1930s a man called Marcus Garvey was fighting for black people to come together and build themselves up to challenge racism. Garvey said that people must look to Africa to a place called Ethiopia because there would be a king crowned there. And there was a king born, Haile Selassie. Ethiopia was the only African country at the time that was not conquered.

"So this place, Ethiopia, was very special. Some people in Jamaica thought we should look up to this man Haile Selassie," McMillan explained. "And that is how the Rastas began. And they would just let their hair grow and grow. Some people didn't like the Rastas. They thought 'This is dangerous! This is ugly!' But it influenced a lot of people in the 1970s. At the time when this poster came out, black people did not see too many images of themselves. So this poster was really important. In the posters, we can see ourselves, and we can see how beautiful we are."

McMillan told the children about how the Walter Rodney Bookstore, when it operated in South Ealing, was a target of racist attacks. "In the 1970s when I was growing up, some black bookshops were attacked by groups like the National Front and the KKK. These people did not like what these black people were doing in bookshops. So they sprayed graffiti on the doors. They threatened to bomb them. Someone sent a bomb and there was a big fire. These attacks were going on all over the country. Jessica and Eric Huntley wrote letters to the police and government to get justice."

McMillan continued. "Walter Rodney. Have you heard of him?"
The children mumbled no.

"He was an activist. Do you know what an activist is? He fought for freedom. He fought for people's rights. Activists may do demonstrations in the street. They may write things to raise awareness so that people know what is going on. Walter Rodney made a lot of speeches in the Caribbean about people's rights. His speeches became part of the first book that Bogle-L'Ouverture published. Sometimes when people do that, the people in power don't like that very much."

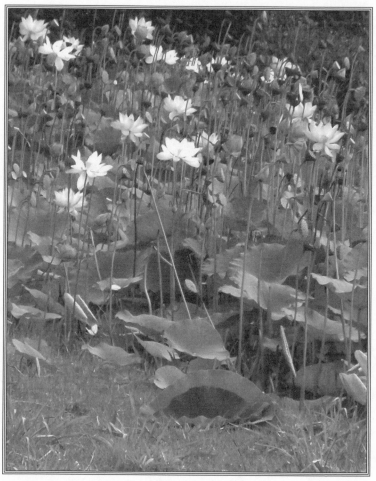

The lotus lily, a symbol of purity and renewal, grows freely in Georgetown, Guyana.
Photo by Nigel Durrant.

7

Lotus

May it come soon, that clear, sweet
day, when some new, unwavering
voice may—above all this vestigial,
neurotic din of empire, above all
absurd vindications, above this fucking
godawful clamour—say simply,
I am
here

—*Ruel Johnson, "Retour au Pays Natal"*

"Baby!"

Ruel Johnson is sitting in his living room on the top floor of an apartment building in a noisy, dense part of Georgetown. He is calling out to his girlfriend of two years, Sinah Kloss. She is a German anthropologist studying religion and material culture in a rural Indo-Guyanese village in the countryside. We are days from Guyana's 2015 national elections.

"You know what happened to me? Guess what happened to me? Make a good guess. Guess why I can't work tonight—which is

probably a good thing. Make a good list—relative to what happened today."

The couple shares the fifth-floor walkup. A breeze passes through open windows giving a bird's-eye view of the city and the controversial Marriott hotel Chinese contractors are building. The rains lash down on the roof so violently we have to shout over each other to be heard.

"You forgot your laptop?" Sinah guesses. She stands in front of their tiny kitchen, waiting for him to light the pilot to the gas stove.

"No."

"Your power cord?"

"I forgot my power cord at the Oasis."

"Sometimes, karma." Sinah shrugs.

Sinah apologizes about the state of the apartment, which is stacked with a flurry of books and papers typical of a home turned over to the writing life. She stays in back in the bedroom working, but breezes in and out of our conversation as she refills our water and serves us baked treats. Her blue eyes and blond hair stand out in Guyana, which has few Europeans left. She is a warm soul, and our interactions flow in a natural and easy way. Ruel dedicated his second book, *Fictions*, which won his second Guyana Prize for Literature in 2013, to Sinah and his son from a previous relationship, Aidan. She has helped to make critical connections for Ruel. He met a representative from the Prince Claus Fund for Cultural Development while at a conference in the Netherlands with her. She set up a series of poetry readings for Ruel at her university in Heidelberg. She has tagged along with him on trips to Suriname and Trinidad.

Between his second home at the expat magnet, the Oasis Café, and his reputation on Facebook, Ruel tends to attract people outside the country. Ruel has "the eyes of the [Caribbean] Diaspora" as U.S.-

based web radio host Selwyn Collins noted.[1] He's "known in cyber-space as one of the brilliant upcoming leaders in Guyana." But like many in the diaspora, Dr. Vibert Cambridge, the scholar who leads the Guyana Cultural Association of New York, finds that Johnson's abrasive, go-for-the-jugular style can distract from his larger points. "Put it this way—each generation produces a Ruel Johnson," said Cambridge, an Ohio University professor emeritus. "He's a confi-dent young man. He's a young, virile writer. Generally, I think he has not risen to the rank of a Martin Carter. But you always have these persons who are focal points in a generation. I think with this new technology that attribute is amplified."

There's an interesting tension in Johnson's work, this interplay of Inside and Outside. In his award-winning short stories, John-son's characters host a revolving door of returning relatives, lovers, and interested academics from abroad, or, in the local parlance, "Outside." But his characters' gazes are focused "Inside," to the Guyana where they go to college, mine gold, cut sugarcane, hunt jaguars, succumb to jealous rage and sexual abuse. Their fortitude is severely tested by the country's lack of development and cultural wars at home and in public life.

Johnson and his characters inhabit their space in ways that push back hard against the cliché of the shipwrecked Caribbean artist after Empire. Statistically, though, marooned is an apt way to think about modern life in Guyana, where middle-class flight and brain drain are endemic. Nearly 55 percent of the people born in Guyana live "Outside."[2] It has the ninth highest migration rate in the world. About seven thousand Guyanese leave each year for the United States alone. And Inside, hope is also in high demand. Recall Guy-ana's appalling suicide rate—the world's highest.

Johnson's poetry rejects the narrative of diasporic writers seeking

to "Return! Return! Vindicate!" He sees his survival as an artist committed to living and working in the West Indies as the real triumph. He is committed to the Inside, not just for authorship but as the site of the production of literature as well. As I watch him furiously typing on Facebook as the last embers of his MacBook die, fact-checking and counteracting myths and government propaganda in real time, it is clear he sees the fight as bigger than his own desire to make a living. He is fighting to break off muzzles. He is clearing a space for anyone to be a Guyanese artist that is "unbought and unbossed," to quote another daughter of Guyana, former U.S. congresswoman and presidential candidate Shirley Chisholm.[3]

Every day, he gets more people on the inside of the PPP government feeding him information about corruption. He wants to tear himself away from Facebook, but with each post he feels he is building momentum. As we speak, private Facebook messages stream in from people of many different ethnicities saying that they support him, and urging him to keep up the fight. I wonder though. Of course the corruption must end. But doesn't Guyana face even bigger issues? What about lack of infrastructure? Don't many of the problems stem from a lack of money? This is not a matter of waiting for Superman as much as it is math.

"There *is* money," Johnson insists. The people in charge of investing it are just "idiots." He rattles off several examples of bungled investments in technology, the environment, and to preserve the cultural heritage. He shows me photographs he got of the damaged collection at the museum and goes off on a tear on the next exposé he is working on for *The Mosquito*. Earlier at Mashramani, he surprised me by saying if the election goes badly, he will have to look for opportunities elsewhere. But looking at the sparkle in his eye, his

adrenaline pumping at the game of cat-and-mouse, I really question whether he would jump ship.

"You like this stuff," I tease Johnson. Then I turn to Kloss. "He doesn't want to leave this. He loves this."

"That's what I keep saying. Even if things change, if everything turns out the way he wants it. . . . Well, you know what I mean."

I don't exactly, but I will several weeks later. I learn how tensions over the election do irreparable harm to their relationship. With each Facebook post, it is unclear if he is getting closer to his vision of a new Guyana, or closer to losing his mind.

In November 2014 instead of facing a "no-confidence" vote from Parliament, the PPP president Ramotar suspended the body. Under international pressure, Ramotar relented and set national elections for May 11, 2015. If he was campaigning for votes, he had a strange way of showing it. There were lighthearted moments, like when I saw him wining down on a voter during Mashramani. But there were also darker moments: recall when a teacher in an Amerindian village was roughed up by presidential guards during a campaign visit.[4]

People were still mad about the health minister (the same guy who gave me his phone number during Mashramani), who was later caught on tape threatening to order his staff to "slap" and "rape" a female protestor complaining of the sad state of the public hospital. Three months before the 2015 election, senior ministers defended the promotion of two police officers involved in the 2009 torture of a fourteen-year-old Afro-Guyanese boy whose genitals were doused with chemicals and set aflame during a police interrogation.[5] Memories are still fresh of the PPP party's close ties to a drug lord named Shaheed "Roger" Khan. Before the U.S. government convicted Khan (and his American lawyer, famed for defending the mobster

whose story was the basis of the movie Goodfellas)[6] in 2009 of witness intimidation, murder, and drug racketeering charges, he worked closely with the PPP government on "security." Khan's cocaine profits funded a "phantom death squad" of former police officers that executed hundreds of mostly Afro-Guyanese.[7]

"The most recent electoral contest might be seen as many things: a referendum on corruption, a test of coalition politics, or an effort to transcend ethnic voting," wrote Gaiutra Badahur, who covered the elections for *Foreign Policy* magazine.[8]

"But beneath all those skins. . . . It felt like history was on the ballot."

That is definitely the decorated artist Bernadette Persaud's view of the contest. Not so much as a history of racial strife on the ballot but "amnesia on all sides." The PPP have been enriching themselves for years at the expense of Guyana's development, and using hearings like the Walter Rodney Commission of Inquiry to revive the ghost of the boogeyman, the PNC's Afro-Guyanese leader Burnham, as a warning to voters. The ruling People's Progressive Party still believes the Indian vote is their birthright. They also have never admitted to their role in sabotaging the previous regime. "We just felt the PPP were saints. Everything is shrouded. Nothing has been revealed. Nothing has been discussed."

On the other hand, Mrs. Persaud believes that A Partnership for National Union (APNU), the multiracial coalition party, includes too many faces from the past—most notably the presidential candidate David Granger, who was a brigadier general in Burnham's PNC Army. "The other little parties that are part of the coalition are tokenistic. The people—everybody knows that it is the PNC."

Mrs. Persaud, hardened by the layers of duplicity and cynicism many Guyanese have adopted to survive, felt fairly despondent at

choices voters faced. The contest was between the ruling political party that cuffed Guyanese in the face yesterday, and the party that cuffed Guyanese in the face when it ruled a generation before. "Me, I'm not voting for any of them. I will become like my mother: a Jehovah's Witness," she laughs. "She says you have the government of God, and you are waiting for thy Kingdom come. The paradise. The government that will give you paradise? That's God's government."

The place where the artist retreats to vent frustrations with the failings of man is a home studio, a modest two-story house filled with acrylic landscapes. It's just a twenty-minute cab ride from Georgetown. Jhindi flags of her neighbor flap in the wind. The balloons for her husband Byro's recent seventieth birthday celebration are still there. She and her husband tenderly dote on their forty-four-year-old son, Sunil, who is mentally disabled and is not feeling well. Vivid Guyana landscapes and paintings from her Jhindi flag series are everywhere, many of them captioned with excerpts from Martin Carter poems. Mrs. Persaud serves me some curried chicken and rice.

She has mocked the PPP, shrouding her critique in beautiful brushstrokes, as vividly as she has the PNC, but she asks that I leave out details for the safety of her and her family. In her painting, the lotus lily has become a powerful symbol of Guyana's potential. "It opened me to ancestral cultural ideas," she told Ruel Johnson in an interview for *Caribbean Beat* magazine.[9] "I realised that this lily that was so sacred to my ancestors had never held any real significance in my life. It had withered. For me it came to reflect the state of what was happening in Guyana at the time, the decay that was overtaking everything."

Recently, her canvases have turned to more spiritual matters. "I'm still searching for God, but God is eluding me. I'm looking in

Hinduism, and Islam and the Koran. I read the Bible over and over again when I was young. So, in a way I am still searching, but it eludes me. I can't say I'm an atheist. Sometimes you don't believe in anything. It doesn't seem as if God exists. But then you meet some really good people."

One of them is Ameena Gafoor, editor of the *Arts Journal*. The day of my visit, Gafoor stopped by to hand off proofs of the latest edition of the *Arts Journal*, one of the highest-quality periodicals of arts criticism in the region. Mrs. Persaud is the arts editor. They were completely unsatisfied with the quality of the print reproduction. The printers better watch out, lest "they see two Draculas coming, to beat them down and make them do over certain things," Mrs. Persaud says. And then she laughs.

Science has complicated her view of the universe. Since the lat-

Bernadette Persaud and Ameena Gafoor examine the production values for the most recent edition of the *Arts Journal*, one of the most high-quality publications in the Caribbean.

est research shows the universe has always existed, there was no big bang of creation, Mrs. Persaud reaches into her canvas to explore other explanations for how we got here that elude the infinite human mind. This search draws her to the metaphysics of Hinduism. "Time is our own creation. Time can only be the goddess of time, Kali, with her skulls all around her, consuming us all," she says, pointing to her piece in progress, which depicts the god Shiva presiding over time. "When he dances his dance cycle, he stops, the world comes to an end. The cosmos, everything comes to an end."

"For me, the idea of God is also beyond comprehension. So I prefer to leave it that way, and use squares and circles in my paintings. I'm showing the limited mind, and the mind that is beyond comprehension. The squares are symbols of the house, and the circles are the limited, contained mind. The square and the circle—all the time there is that interaction. That is the limited perception that we have of things."

Mrs. Persaud believes that just as the human mind has constructed time, it has constructed ideas of race. "We are conditioned by race and class and nationality. All the time you cannot escape that. The work of art can be raced. It can be classed. It can be gendered—in a good way. There is nothing really raceless. Even if you are mixed you have tendencies in you," she says, and we both giggle.

Government slogans that insist on the unity or oneness of man are ridiculous, she says. There are many peoples. If you are realistic, you accept diversity as the civilized choice. "This is human nature. It's part of us. It's part of our makeup. On the one side of us, we have the destructive tendency, Shiva. On the other side, we have Brahma the creator. And on the other side we have part of us that likes to conserve and to sustain, that is Vishnu. So it is a psychological model. Shiva, Brahma, Vishnu, which is part of us. We can't do anything

about it. Today I'm in a destructive mood and I want to get rid of it. Tomorrow, I'm creative."

Will the next national elections be creative?

"I'm looking at the youth vote and what they really think. My husband says, 'We don't know what [the APNU coalition] is going to do.' I say, I know damn well what they are going to do. I see it all around me."

Byro Persaud is a warm and genial fellow. He ferried us around and greeted me like a daughter when I met him the second time. When I told him how much I admire his wife, he didn't miss a beat. "Take she!" he deadpanned. Once, in the early 1980s Burnham era, he was on a break from his job working as general manager at Guyana Stores (formerly Booker's Stores) in downtown Georgetown. He saw Mrs. Persaud and other teachers holding a protest sign reading, "Are you Mice or Men?" He simply walked past her.

Byro Persaud avoids the topic of elections with his Indian neighbors. Those conversations become too intense. But he's made his decision. "In Guyana, we have always voted by race, and it has not served us well," he tells me. "I think it is time for a change."

Three weeks before the election, my teenage cousin at the University of Guyana calls me in Washington to check in. The campus is buzzing about the news that Courtney Crum-Ewing, an activist against the ruling PPP government, was killed. My first instinct is to check Ruel's Facebook feed. When I see him posting photos from the protest, I am relieved that Ruel is safe. The killing was still shocking. The victim was the Afro-Guyanese activist Courtney Crum-Ewing, who as you might recall from chapter 3 had staged weeks of protests against the attorney general, who was caught on tape threatening to murder the publisher of a major newspaper.

The image of Crum-Ewing's lifeless body lying in the middle of the street—right next to his bullhorn—will haunt me forever.

President Donald Ramotar's reaction to the activist's murder is chilling. "He was no threat to the government," Ramotar tells the Berbice Chamber of Commerce, according to the *Kaieteur News*.[10] "He was a nuisance value more than anything else. He was spreading a lot of racist talk on his Facebook page." Ramotar speculated that the opposition party was responsible. "If this death was political as they are saying, well, I would say that he was a pawn, that he was sacrificed for their own political ends because we certainly don't have anything to gain from this activity."

I reach Ruel on Facebook to see if he is taking any extra security precautions. He is coldly analytical about the situation. "I'm always security conscious, but I also realise that he was an easy target," he tells me in a message.

Why, I wonder?

"Variety of factors."

"1) He was a loner and hence easier to target.

"2) It was calculated, considering he wasn't Freddie [Kissoon],[11] or [Mark] Benschop[12] or me. He was strident, but the backlash has not been as powerful as if it were any one of us. They could easily assassinate his character after.

"3) Opportunity. He was doing so in a dark area. The Police Force can easily claim inadequate evidence. The fact is that a police patrol unconnected to the area turned up minutes after the shooting."

Ruel realizes that his own outspokenness and lack of major institutional affiliation could make him a target. "But there are greater repercussions for offing me. . . . This benefits them [the PPP] in that it generates fear."

It also brings tensions to a boil within Ruel's own house. I decided to check in with Sinah to see how she was holding up.

When I catch up with Sinah on Skype, in the last week of April 2015, she is back in her childhood home in Germany, between field visits. She plans to return to Guyana shortly after the May 11 elections. She is holding up as well as can be expected. "I really appreciate what he's doing. It is wonderful. He has to do it. But I really don't like when he gets so harsh on Facebook. I have always been worried. And I know his mother is, too."

Sinah says Ruel is certain that his reputation will shield him. But that certitude can only apply to people who are in their right mind. In Guyana, an estimated one-third of the population has mental illnesses they are not aware of. "There is really no mental health care in Guyana," she says. "So there are a lot of weird people walking around. I never felt threatened. [Ruel] always says that nothing can happen to him. I was kind of sure and trusting [of] him. But when this Crum-Ewing thing happened, I had a moment when I got stressed out. I was crying. He just kept saying that nothing can happen to him. I think he is telling himself this."

Shortly after Crum-Ewing's murder, she wanted to make a run to the Kitty Market. Sinah asked Ruel for his help carrying the groceries back to their apartment. He was consumed with Facebook and kept putting her off. She asked one final time; it was already dark— too late for him to travel the streets of Georgetown. "He is definitely considering his steps. And he is pretending."

That leads to the question: is the idea that Ruel is having an impact on Guyana voters also another pretense? For all the promise of social media, it rams into the immovable object of a developing infrastructure. A good portion of the country does not have electricity, let alone access to the Internet. There is a vigorous newspaper culture

with several daily newspapers. But in many of the Indian villages where Sinah conducted her research, they mostly speak creolized English. So they would struggle to understand rigorous standard English in Ruel's near-weekly public letters.

"A lot of the politics happens there—especially in the Indian community in Berbice. Not too many people know about him and his works. I think within Georgetown and certain circles, he has great impact. Once you leave these places, I wonder if people are aware at all."

Even if the PPP retains power, she highly doubts that Ruel will leave. Just as social media opens the possibility of renewal, it also can be a ball and chain. In their trips to Germany, the Netherlands, Trinidad, and Suriname, Facebook has always exerted an inescapable pull. On some trips, Ruel never left their hotel room. He tried an app called SelfControl, but even that did not work. "I don't want to call it an obsession, but even when he was in Germany or other places, he would stick to the social media and he would not let go of it.

"He is never leaving Guyana. Always with his mind, he is always staying there. I don't know if he wants to leave, [or if] he can. It is not only positive that I am saying that."

That is one of the reasons why Sinah recently decided to disconnect from him after more than two years invested in their relationship. As the campaign heats up, he has not been himself. She has noticed it with other interracial couples, too. The racism is getting to everyone. A turning point was when a close, trusted Indian ally, a young woman he had mentored and worked with on the Janus Cultural Policy Initiative, betrayed him. His paranoia grew after that. Ruel began to question Sinah about her fieldwork in the Indian villages where she was exposed to anti-African beliefs. He told Sinah

that if she does not directly challenge racist attitudes, she is part of the problem. Sinah found this hurtful. "My job is not to provoke social change. I am supposed to analyze it. I am not supposed to say what is right or wrong.

"I almost think he is losing himself. He is doing this for [his] country, you know, some sort of *Braveheart* rhetoric. For the country, he is wanting to sacrifice everything. That is nothing that as his girlfriend you want to hear. So it is a bit too much."

She believes he is genuine about making positive change. But she believes he is sacrificing too much of himself and not taking enough time for self-care. "He always says, the change in government will allow him to do his work in Guyana, to create what he wants to create. Right now, he is not really writing so much. He is more of a campaigner and political activist. Maybe I don't understand because the pressure is not on me. No one cares if I don't comment to Facebook in three hours. I don't really know the pressure that he has."

Ruel's work establishing workshops and a regional publishing infrastructure was very important. "That is what was so positive about Ruel's approach. He was really trying to build this publishing house. He had this talk in Carifesta about how to bring publishing back to the Caribbean. I really admire this initiative. At this point, he is only [doing political] campaigning. I really hope that after May 11, he will have time to do that work again. He can't do both at the same time. When he writes, he writes like mad. When he campaigns, he campaigns like mad. He will go to it when it is done, I am pretty sure about that."

Whatever he chooses to do, her support will have to come from a distance. "It is really hard. I am just really hoping that he gets back to the Ruel that writes also."

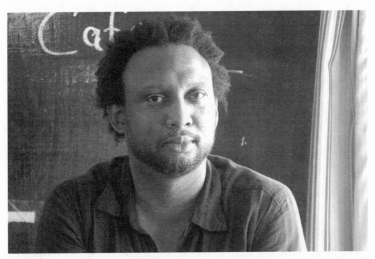

Ruel Johnson was born the year Walter Rodney was assassinated. "Every generation produces a Ruel Johnson," said cultural scholar Vibert Cambridge. Photo by Akola Thompson.

I left my Skype call with Sinah feeling depressed. Without hope for change, what is there?

Guyana barely registers in world affairs and is certainly the last thing on the mind of the global world of arts and letters. But the Guyanese poet Martin Carter may have never said a truer thing: no matter where we live or what we do, all of our mouths are muzzled in the quest for survival. In Bernadette Persaud and Ruel Johnson we have two clear windows into this essential challenge.

Mrs. Persaud paints in soothing impressionistic strokes but, as they say, don't let the smooth taste fool you. An iconoclastic and discerning critic, she sniffs out hypocrisy and anti-intellectualism in all parties, races, and genders. Beneath the seductive haze and polite formality, she uses her writing and canvas to mercilessly flog those in power. She poses bold questions of the earthly and spiritual realms,

pushing past the boundaries of what is knowable in ways only art can do. Like Kara Walker, she has a supremely confident voice and a certain hand. Her work often floats above the petty disputes of the day. She looks down from on high to settle cosmic scores. Her clear and uncompromising voice and deep knowledge articulate many of the essential paradoxes of being human anywhere. She is a global original.

Johnson, too, is a deeply knowledgeable, piercing, and effective social critic. He is a cultural utopianist in the tradition of negritude developed in part by poet-politician Aimé Césaire, to whom his writing frequently alludes. My husband, Rudy, remarked that he brought to mind our college friend, the decorated writer Ta-Nehisi Coates. "He's like the Ta-Nehisi of Guyana!" You could say that. He is definitely a public intellectual with a sharp H.L. Mencken–esque brusqueness and a blistering pen. It is hard to compare the scale of opportunity. Of course, in the United States and Europe, it is not easy to become a writer, but there are many independently funded paths to the writing life. In a sparsely populated, developing country like Guyana, to dare to write for a living requires a special kind of brass. In the years I have known Ruel, I have seen him evolve from a writer to an activist to someone who uses his words to bend history in real time. Ruel's unwavering belief in his own talents and his right to survive in society as a writer, along with his refusal to be funded and muzzled by a corrupt government, means that he has had to invent himself.

These are questions for all of us. Will our struggling town or city be reinvented as the next cool creative hub? Will our global cultural and political establishments reform? Is there a reason to be optimistic about the future of societies suffocated by a history of racial strife and economic struggle? It is impossible to measure how any single person's art or cultural activism pushes the needle.

Public rituals like Mashramani create space for the whole society to have a conversation. In a globalized culture, those conversations can be loud—overwhelming. There are too many different smells, too many clashing flavors, too many competing voices in our heads. That's also why it is equally important to have clear, singular voices that rise above the din. As a nineteen-year-old University of Guyana economics major told me during an arts policy discussion, "If you want to have a change, you actually have to have someone who is quite imaginative." "Someone isn't smart based on how much they know. It's about how much they can imagine what's possible. If you can imagine a way of solving it, then you can solve it." One role of the artist is to be one of these crazy people who can see a vision for the larger society and blaze a path that takes the rest of us there. Sometimes we get there in our lifetimes. Sometimes, like it did for Walter Rodney, the path ends too soon. Often the artist creates a clear view of the unseen. These are just a few of many critical roles of the arts in any society. Regardless of what happens politically, these are the victors in the ongoing process of reconciling the quarreling ghosts of the past, and the art and culture we will make in the future.

When the May 11 election day finally came, my anxiety levels were on ten. I barely could watch the results—and I was thousands of miles away in my home in Washington, D.C.! There were reports of some drama at the polls—some minor incidents of violence. Ninety-year-old Jimmy Carter, who, as you may recall from chapter 5, helped to atone for the imperial sins of the past by facilitating Guyana's very first free and fair elections in 1992, arrived in Georgetown. When he became ill and left early, it seemed to be an ominous sign. But then on May 15, the Carter Center for Peace circulated a press release from former president Jimmy Carter: "I issued a statement calling for all polling results to be published and for parties to

accept them. The APNU's Granger prevailed with 206,817 votes to 201,457 to the PPP. . . . If finally implemented, this will be the first change in Guyanese party leadership since 1992."

I logged on to Facebook. Someone tagged Ruel Johnson in a photo and post on May 14, 2015:

> *Guyana, while you drink and celebrate, please raise your glass(es) to this young man—Ruel Johnson. He fought long and hard, and his messages were well received by the young people, while exposing the corruption within the PPP/C.*
>
> *You intelligent bastard! # OneLove*

Voters took to the streets to celebrate the APNU victory—in the rain, of course. Photo courtesy of the *Stabroek News*.

think outside

provide a platform for civil dialogue

remember mourn

reflect the times in which we live

express unifying responses generate profits

WHY ART? to heal

mirror society

anticipate what's coming next celebrate emotions

disrupt societal norms

spread knowledge make a living

make beauty present predict changes in society

entertain criticize society

be a medium for ritual and civic engagement

build common experiences and ties

express a belief system

make meaning of life

A detail from the first IF Arts Policy Discussion guide. Photo illustration by Calida Rawles for the Interactivity Foundation.

Acknowledgments

I am deeply grateful to the Interactivity Foundation (IF) for its commitment to creating platforms for generating new possibilities for public policy. IF's vice president, Jeff Prudhomme, suggested "The Future of the Arts & Society" as the topic for my first project as an IF fellow, which planted the seeds for this book. Thanks to IF trustees: Jack Byrd, Adolf Gundersen, Alan Freitag, Larry Jackley, Joe Powell, Allison R. Brown, and IF's founder, the late Jay "Julius" Stern. And to my fellow IF fellows: Dennis Boyer, Pete Shively, Mark Notturno, Ieva Notturno, Sue Goodnea Lea, Shannon Wheatley Harman—all gave crucial feedback on drafts of the initial arts policy project.

Julie Enszer, thank you for seeing something in my original IF "Arts & Society" project, and believing that there were some conceptual possibilities that could be developed into a narrative for The New Press. Ruel Johnson and Bernadette Persaud, thank you for your excellence, and for personifying art in action, culture in defiance. My cousin Carlos Benn organized and facilitated IF "Arts & Society" discussions in Guyana and helped with music and interview transcriptions. Thanks to Vidyaratha Kissoon, Sherlina Nageer, Alicia Martin, Zitronie George, Zitman George, Calvin Benn, Kimberly Benn, Priya Singh, Maureen Marks-Mendosa, Akima

McPherson, Syeada Manbodh, Ronald Gordon, Sinah Kloss, Bibi Nariefa Abrahim, Ryan Ramcharran, Muniram Deonaraine, who all are dreaming of and working for a better Guyana.

Thanks to the Jamaican critic Annie Paul for telling me about Ruel and proving we are not all wasting our time on Twitter. Paul Gilroy pointed me to the Artist & Empire exhibit at the Tate in London. And thanks to my Guyanese diaspora massive, whose work, connections, and conversations informed and inspired me: Grace Aneiza Ali, Hew Locke, Oonya Kempadoo, Vibert and Pat Cambridge, John R. Rickford, Walter Edwards, Nigel Westmaas, Gaiutra Bahadur, Gabrielle Smith-Barrow, Joy Ford Austin, Rev. Mother Roxanne Hunte.

Thanks for your eyes: Deb Heard, Russell R. Rickford, Delece Smith-Barrow, Derek Andrews, E. Ethelbert Miller, Reggie Royston, Teresa Wiltz, Natalie Y. Moore. Thanks W. Paul Coates for insights into the triangular trade of black publishing. London curator Dr. Michael McMillan shared archival research he used to produce the groundbreaking *No Colour Bar* exhibit at the Guildhall. Thanks to the Women Writers of Color brunch group for quarterly affirmation. Thanks to my colleagues at Howard University's Communication, Culture and Media Studies (CCMS) department and the entire School of Communications including Mark E. Beckford for the Jamaica connections. My uncle Ovid Benn's colorful stories of his life mining gold inspired me to begin traveling to Guyana as an adult. My husband, Rudy McGann, and kids, Maverick and Maven, let me drag them along for the ride.

I save my parents for last even though thank you is not enough. To my dad, Terrence Hopkinson, the arts and expression had nothing to do with art or politics, fame or fortune; they were simply water or air. He was a dreamer throughout his entire life but did

not live long enough to see this book in print. Finally, thanks to my mother, Serena Hopkinson, my inspiration in all things. Mum, thanks for riding shotgun on this: the line edits, gut checks, and holding me up on this (often literally) rocky ride. Mama, we made it!!! I'll send you the bill.

Notes

1: Your Eyes Pass Me

1. Bernadette Persaud, "The Sacred Mission of the Artist: Reflections and Concerns of an Artist in a Multiracial Society," *Caricom Perspective*, no. 58 and 59 double issue (January–June 1993): 19.

2. Clifford Kraussjan, "With a Major Oil Discovery, Guyana Is Poised to Become a Top Producer," *The New York Times*, January 13, 2017.

3. Hilary Beckles, *Britain's Black Debt: Reparations for Slavery and Native Genocide* (Kingston, Jamaica: University of the West Indies Press, 2013); Nicholas Draper, *The Price of Emancipation: Slave Ownership, Compensation and British Society at the End of Slavery* (Cambridge: Cambridge University Press, 2010); S.G. Checkland, *The Gladstones: A Family Biography 1764–1851* (Cambridge: Cambridge University Press, 2008); David Olusoga, "The History of British Slave Ownership Has Been Buried: Now Its Scale Can Be Revealed," *The Guardian*, July 11, 2015.

4. Jesse Coleman, "Rex Tillerson's Conflict of Interest in Guyana: Tillerson will write the rules for Exxon's massive oil find in Guyana," January 17, 2017, http://www.greenpeace.org/usa/research/rex-tillersons-conflict-of-interest-in-guyana.

5. Guyana has been vying with Guatemala for second poorest in the Americas for years. *World Factbook 2013–14*. Washington, DC: Central Intelligence Agency, 2013, http://www.cia.gov/library/publications/the-world-factbook/index.html.

6. Farahnaz Mohammed, "Guyana: Mental Illness, Witchcraft, and the Highest Suicide Rate in the World," *The Guardian*, June 3, 2015.

7. Cheddi Jagan, *The West on Trial: My Fight for Guyana's Freedom* (London: Hansib Caribbean, 1997). Many PPP members were trained in Russia.

8. Some criticized the PPP government for awarding a $58 million (USD) contract to build a Marriott hotel to a Chinese company that imported Chinese workers and gave virtually no jobs to Guyanese taxpayers, who footed the bill.

9. The Guyana government has always underwritten the costs of making the

costumes and floats, however, it is unclear when the practice of paying people to party was established.

10. One of the templates of activities for Mashramani "came with Queen Victoria Jubilee—Centennial of the colony. I refer to those as 'bread and circus.'" Vibert C. Cambridge, personal interview, February 20, 2015; Vibert C. Cambridge, *Musical Life in Guyana: History and Politics of Controlling Creativity* (Jackson: University Press of Mississippi, 2015).

11. Vibert C. Cambridge, personal correspondence: "Calypsonians had always been commenting on politics in Guyana and that there was evidence that efforts were being made to have calypsonians sing in praise of Burnham and the PNC. Those efforts came across as contrived and were neither credible nor entertaining. Mighty Rebel lost calypso crown often because he was critical of government and postcolonial ruling class. Calypsonians got paid to participate."

12. Girish Gupta, "In Guyana, Feeling Stifled After Needling Government in Song," *The New York Times*, December 5, 2013.

13. Thanks to Ruel Johnson for introducing the term "Afro-Saxon" to me.

14. "Indians looked to India for "high culture." There also may be elements of what Vibert C. Cambridge calls "Victorian respectability" in the backlash against Mashramani. Cambridge, *Musical Life in Guyana*, 174.

15. Dmitri Allicock, "The Birth of Guyana's Mashramani," *Oh Beautiful Guyana*, ohbeautifulguyana.files.wordpress.com/2014/03/the-birth-of-guyanas -mashramani.pdf.

16. Walter Edwards, personal e-mail correspondence, June 12, 2016.

17. *Mashramani: Guyana's Official 45th Republic Anniversary Commemorative Magazine*, 6th edition, https://issuu.com/cmgguyana/docs/mash_2015 _magazine_online.

18. Stephen G. Rabe, *U.S. Intervention in British Guiana: A Cold War Story* (Chapel Hill: University of North Carolina Press, 2005).

19. Cambridge, *Musical Life in Guyana*, 155. In general, Vibert C. Cambridge's book on the musical culture of Guyana is an invaluable text to aid in understanding Mashramani and the country's musical cultures generally.

20. Kate Quinn, ed., *Black Power in the Caribbean* (Gainesville: University Press of Florida, 2014).

21. On February 23, 1970, Guyana becomes the first co-operative republic in the world. The descriptor "co-operative" refers to burial societies organized by enslaved Africans. Cambridge notes that this tradition was used among both African and Indian communities. Cambridge, *Musical Life in Guyana: History and Politics of Controlling Creativity* (Jackson: University Press of Mississippi, 2015); P.H. Daly, "Revolution to Republic." *Daily Chronicle*, 1970.

22. V.S. Naipaul, *Middle Passage: The Caribbean Revisited*, reprint ed. (New York: Vintage, 2002).

23. For an extended discussion of Burnham's vision of culture, see Cambridge, *Musical Life in Guyana*, 194.

24. Moe Taylor, "'Only a Disciplined People Can Build a Nation': North Korean Mass Games and Third Worldism in Guyana, 1980–1992," *Japan Focus* 13, issue 4, no. 2 (January 26, 2015).

25. A.J. Seymour, *Cultural Policy in Guyana* (Paris: UNESCO, 1977).

26. My maternal grandmother's features are most recognizably Amerindian and she was raised by her Arawak grandmother. But her grandfather was East Indian and her mother had some African roots. When I ask her, at age eighty-six, what her race is, she just laughs. "What am I? That is the question! Me skin black . . . I am not white—I know that!" she says, and she laughs some more.

27. Guyana's religious breakdown in 2002 was estimated to be Protestant 30.5% (Pentecostal 16.9%, Anglican 6.9%, Seventh Day Adventist 5%, Methodist 1.7%), Hindu 28.4%, Roman Catholic 8.1%, Muslim 7.2%, Jehovah's Witness 1.1%, other Christian 17.7%, other 1.9%, none 4.3%, unspecified 0.9%. *The World Factbook* (Washington, DC: Central Intelligence Agency, continually updated), https://www.cia.gov/library/publications/the-world-factbook.

28. "Gov't to Hand Out 6,000 Solar Panels in Hinterland—Vote-Buying, Tokenism, Granger Calls It," *Stabroek News*, February 26, 2015, www.stabroeknews.com/2015/news/stories/02/26/govt-hand-6000-solar-panels-hinterland.

29. "Bai Shan Lin Leases 27.4 Acres of Amerindian Land at $5,000 an Acre," *Kaieteur News*, February 26, 2015, www.kaieteurnewsonline.com/2015/02/26/bai-shan-lin-leases-27-4-acres-of-amerindian-land-at-5000-an-acre. Also, please see the work of the University of British Columbia's Janet Bulkan, who has been sounding the alarm about the destruction of Guyana's rainforests since 2005. Janet Bulkan, "In Guyana, the Future of the Forests—and the Rule of Law—Hangs in the Balance," *DemocraciaAbierta*, September 7, 2016, opendemocracy.net/democraciaabierta/janette-bulkan/in-guyana-future-of-forests-and-rule-of-law-hangs-in-balance.

2: Lady at the Gate

1. Bernadette Persaud, "Art, Comrade, Makes Nothing Happen Here," *Contending with Destiny: The Caribbean in the 21st Century*, eds. Denis Benn and Kenneth Hall (Kingston, Jamaica: Ian Randle Publishers, 2000).

2. The title of Persaud's 2014 exhibit *As New and As Old* is borrowed from a poem by the Guyanese writer Martin Carter who has inspired much of Persaud's art.

3. Bernadette Persaud, "The new Management Committee should review the housing and care of the national art collection," letter to the editor, *Stabroek News*, July 2, 2014.

4. "Gentleman Under the Sky" is Persaud's 1991 acrylic painting included in the *Spirit of Revolution: Celebrating Guyana's 45th Republic Anniversary* show from February 19 to March 21, 2015, at the Castellani House; it was part of the later series that targeted the U.S. invasion of Iraq under President George W. Bush.

5. Persaud, "Art, Comrade, Makes Nothing Happen Here," 575.

6. In 2015 my father recalled attending a party at The Residence with my mom in the late 1960s. He told me Miriam Makeba performed at the party, and that she was romantically linked to Burnham.

7. Judy Slinn and Jennifer Tanburn, *The Booker Story* (Petersborough, UK: Jarrold Publishing, 2003), 95–99.

8. Evelyn A. Williams, *The Art of Denis Williams* (Leeds, UK: Peepal Tree Press, 2012).

9. Ibid., 94.

10. During a labor dispute with sugar workers, Burnham had demanded that other public sector employees replace sugar workers in the fields.

11. Cheddi Jagan, *The West on Trial: My Fight for Guyana's Freedom* (London: Hansib Caribbean, 1997). Jagan said that, at first, his parents were unsure about him bringing home this white woman from Chicago. "My father, in his sentimental moments, credited most of the family's progress to her. 'If Cheddi bin marry a coolie gal me pickney would a never get a chance.'"

3: The Oasis

1. Ruel Johnson, *Collected Poems, 2002–2012* (Georgetown: Janus Books, 2012).

2. The Norwegian government paid $80 million (USD) to Guyana for a hydropower project advertised as a component of Guyana's Low Carbon Development Strategy. Political turmoil, lack of regulation, and outrage from indigenous peoples doomed the project. Chris Lang, "Norway Hands over US$80 Million to Increase Deforestation in Guyana," *Redd Monitor*, April 14, 2015, www .redd-monitor.org/2015/04/14/norway-hands-over-us80-million-to-increase -deforestation-in-guyana.

3. The other "oasis" for my children, then eight and eleven, was across Carmichael Street at Guyana's Historic Trust, which hosted a free "heritage" camp for children in their age group, sponsored by the Ministry of Culture, Youth and Sport. Minister Frank Anthony presented them with certificates upon completion of the program, which was televised. It was a highlight of our trip. I tried to get a meeting with Minister Anthony, to both thank him for this project and interview him, many times but was not successful. The closest I got was a scheduled Skype interview, to which an aide showed up and said he would reschedule.

4. Juanita De Barros, "The Garden City of the West Indies," *Order and Place in a Colonial City: Patterns of Struggle and Resistance in Georgetown, British Guiana, 1889–1924* (Montreal: McGill-Queen's University Press: 2003), 16–48.

5. For more on the history of ongoing labor disputes in Georgetown, see "Getting a Handle on Garbage," *Stabroek News*, January 7, 2016, www .stabroeknews.com/2016/opinion/editorial/01/07/getting-handle-garbage.

6. Ruel Johnson, "Mainstreaming Culture in Development," *Kaieteur News*, November 11, 2011, www.kaieteurnewsonline.com/2011/11/06/mainstreaming -culture-in-development.

7. Ruel Johnson, *Fictions* (Georgetown, Guyana: Janus Books, 2012); Ruel Johnson, *Ariadne & Other Stories*, 10th-anniversary edition (Georgetown, Guyana: Janus Books, 2013).

8. Fareeza Hanif, "President Admits to 'Slap' Comments Towards Aishalton Teacher; Says It Is 'Petty,'" *Capitol News Source GY*, May 3, 2015, http:// www.inewsguyana.com/president-admits-to-slap-comments-towards-aishalton -teacher-says-it-is-petty.

9. "Attorney General Reveals Plans to 'Hit' Glenn Lall," *Kaieteur News*, October 27, 2014, www.kaieteurnewsonline.com/2014/10/27/attorney-general -reveals-plans-to-hit-glenn-lall-knews. According to a transcript provided by the newspaper, here is what the Attorney General can be heard saying on the recording: "I think that you should, my first advice to you, is that you should move out of there . . . It is a dangerous fucking place to work, is a dangerous place. I am telling you, read between the lines. This thing not going to go on for long. People not going to take this thing just so. Is a lot of powerful people that this man . . . Wait, nobody never used to bother with he before, right. He used to getaway, get through with all what he publishing. But people get, people get sensitive now."

10. For rebuttals to "creative economy hype," see Dan Atkinson and Larry Elliott, "Talk Is Cheap," *The Guardian*, May 18, 2007, and *Creative Industries for Youth: Unleashing Potential and Growth* (Vienna: UNESCO, 2013), unesco .org/new/fileadmin/MULTIMEDIA/FIELD/Dakar/pdf/EbookCreativeIn dustriesYouth.pdf.

11. Shrinking Cities, *Federal Cultural Foundation*, 2002–2008, www .shrinkingcities.com.

12. Natalie Hopkinson, *Go-Go Live: The Musical Life and Death of a Chocolate City* (Durham, NC: Duke University Press, 2012).

13. The UNESCO Creative Cities Network (UCCN) was created in 2004 to promote cooperation with and among cities that have identified creativity as a strategic factor for sustainable urban development. See en.unesco.org/creative -cities/content/about-us.

14. Richard Florida, *The Rise of the Creative Class* (New York: Basic Books, 2002).

15. Jamie Peck of the University of the British Columbia is one prominent

critic who challenges Florida's neoliberalism and the economic divides created by gentrifying cities.

16. Dr. Carolina E. Robertson, the late Argentinian ethnomusicologist passed on this "table world" concept in a lecture on postmodernism in her field methods class at the University of Maryland in spring 2006.

17. Diana Barrowlough and Zeljka Kozul-Wright, *Creative Industries and Developing Countries: Voice, Choice and Economic Growth* (London and New York: Routledge, 2008).

18. Ibid.

19. Although there was not extensive research on Guyana's cultural sector in the U.N. report, Guyana was mentioned as one of the Caribbean countries to which the Vanus James study of the Caribbean creative sector could be applied. Vanus James, "The Economic Contribution of Copyright Industries in Trinidad and Tobago: Potential and Policies for Economic Transformation," World Intellectual Property Organization: Creative Industries Series no. 7, 2012, wipo.int/export/sites/www/copyright/en/performance/pdf/econ_contribution_cr_tt .pdf.

20. Jordan R. Fisher, "International Port Cities," *About Education*, www .thoughtco.com/international-port-cities-1435660.

21. "What Is the Janus Cultural Policy Initiative?," Janus Ideas, https://januscpi.wordpress.com/about.

22. "Twilight at the Museum: How Corruption and Mismanagement Is Destroying a National Institution," *The Mosquito*, January 27, 2015, http://gtmosquito.com/deep-sting/twilight-at-the-museum.

23. Five years earlier, the same company was revealed to have its U.S. corporate "headquarters" at an address that turned out to be a Brooklyn barbershop. "'Barber Shop' Company Gets $300 MILLION Computer Contracts," *Kaieteur News*, July 21, 2011, www.kaieteurnewsonline.com/2011/07/21/barber-shop -com-300-million-computer-contractspany-gets.

24. "Attempted Arson on National Museum," *Kaieteur News*, January 29, 2015, www.kaieteurnewsonline.com/2015/01/29/attempted-arson-on-national -museum, and Ruel Johnson, "Nous Somme Tout Charlie Hebdo," *The Mosquito*, January 11, 2015, http://gtmosquito.com/the-minority-report/2528.

25. David Dabydeen,"Most of the Poetry Sent to the Caribbean Press by Guyanese Writers Is Doggerel," letter to the editor, *Stabroek News*, May 21, 2013.

26. Matthew Hunte, "Guyana Literary Controversy," *Global Voices*, January 24, 2013, globalvoices.org/2013/01/24/guyana-literary-controversy. Caribbean Press was founded in 2009 after a commitment from President Bharrat Jagdeo of an annual allocation of $100,000 (USD); see "Caribbean Publishing House Established in Guyana," *Repeating Islands*, June 13, 2009. The government-owned Caribbean Press initially published just two emerging

contemporary writers, one of whom was the minister, Frank Anthony's, thirteen-year-old daughter.

Ruel Johnson responded: "Where Dr. Anthony seems to have fallen down considerably however is that he appears confused as to what constitutes personal resources at his disposal and what constitutes public resources." Ruel Johnson's Facebook page, January 3, 2013, www.facebook.com/notes/ruel-Ruel/ashley-anthony-and-the-caribbean-press/10151381727996265.

27. Ruel Johnson, "There Has Been No Announcement of a Policy Shift in Relation to the Caribbean Press," *Stabroek News*, letter to the editor, January 10, 2013, www.stabroeknews.com/2013/opinion/letters/01/10/there-has-been-no-announcement-of-a-policy-shift-in-relation-to-the-caribbean-press.

28. "Minister Anthony Flays Ruel," *Guyana Chronicle*, January 10, 2014, https://guyanachronicle.com/2014/01/10/minister-anthony-flays-ruel-johnson, and "Dr. Anthony Unleashes His Wrath on Ruel Johnson; 'The Man Has Become My Lone Critic,'" *iNews Guyana*, January 10, 2014, www.inewsguyana.com/dr-anthony-unleashes-his-wrath-on-ruel-johnson-the-man-has-become-my-lone-critic.

29. As I mentioned in an earlier footnote, over the course of 2015 and early 2016, I attempted to interview the minister of culture, Frank Anthony. We had a meeting set up on Skype. When I arrived at the appointed time, one of the minister's aides showed up and told me the minister would be unavailable. He never responded to my requests for a follow-up.

30. Amnesty International, "Urgent Action, Political Activist Killed Ahead of Elections: The Killing of a Political Activist in Guyana During the Pre-Electoral Period Fuels Fear That Further Violence and Limitations to Freedom of Expression May Occur," March 17, 2015, www.amnestyusa.org/sites/default/files/uaa06315_0.pdf

4: Sweet Ruins

1. From the book cover of Stewart Brown, ed. *All Are Involved: The Art of Martin Carter* (Leeds, UK: Peepal Tree Press, 2000).

2. Gaiutra Bahadur, *Coolie Woman: The Odyssey of Indenture* (Chicago: University of Chicago Press, 2014).

3. The Havermeyer family began refining sugar in New York City in 1807; their descendants built the refinery on the Williamsburg waterfront location in 1856 and built the latest building in 1882 after a fire. Domino Sugar Corporation History, Funding Universe, www.fundinguniverse.com/company-histories/domino-sugar-corporation-history. In 2004 the plant was shuttered after numerous labor strikes with factory workers complaining about wages and working conditions, which was said the be the longest strike in New York City history. Leigh Raiford and Robin J. Hayes. "Remembering the Workers of the Domino Sugar Factory," *The Atlantic*, July 3, 2014, https://www.theatlantic

.com/business/archive/2014/07/remembering-the-workers-of-the-domino-sugar-factory/373930.

4. Sidney Mintz, *Sweetness and Power* (New York: Penguin Books, 1986), 89.

5. The following weekend, Beyoncé was among those who made the pilgrimage to see the Sugar Sphinx, along with husband, Jay Z, and daughter, Blue Ivy.

6. Andrea Stuart, *Sugar in the Blood: A Family's Story of Slavery and Empire* (London: Vintage. 2013), 73.

7. Edwidge Danticat, "The Price of Sugar," *CreativeTime Reports*, May 5, 2014, creativetimereports.org/2014/05/05/edwidge-danticat-the-price-of-sugar.

8. Voltaire, *Candide*, Enriched Classic edition (New York: Simon & Schuster, 2005).

9. British per capita sugar consumption rose as follows:

1700–9	4 pounds
1720–29	8 pounds
1780–89	12 pounds
1800–9	18 pounds

Sidney Mintz, *Sweetness and Power* (New York: Penguin Books, 1986), 67.

10. Elizabeth Abbott, *Sugar: A Bittersweet History* (New York: Overlook Books, 2010).

11. Edwidge Danticat, *Farming of Bones* (New York: Soho Press, 1998).

12. Junot Dias, *The Brief and Wondrous Life of Oscar Wao* (New York: Riverhead Books, 2008).

13. Winthrop D. Jordan, *White Over Black: American Attitudes toward the Negro, 1550–1812* (Durham: University of North Carolina Press, 1968).

14. "John Hopkinson: Biography," *Legacies of British Slave-ownership*, University College of London, www.ucl.ac.uk/lbs/person/view/-709856825.

15. Barbara Bush, "10 Hard Labor: Women, Childbirth, and Resistance in British Caribbean Slave Societies," *More Than Chattel: Black Women and Slavery in the Americas*, edited by David Barry Gaspar and Darlene Clark Hine (Bloomington: Indiana University Press, 1996).

16. Hazel Woolford, "Gender, Rape and the Guianese Slave Society," www.academia.edu/11393897/Gender_rape_and_the_Guianese_slave_society.

17. S.G. Checkland, *The Gladstones: A Family Biography 1764–1851* (Cambridge: Cambridge University Press, 2008), 183.

18. Nicholas Draper, *The Price of Emancipation: Slave Ownership, Compensation and British Society at the End of Slavery* (Cambridge: Cambridge University Press, 2010), 105.

19. P.H. Daly, "Sex in the Revolution," *Revolution to Republic* (Georgetown, Guyana: Daily Chronicle, 1970). See also "Marjoleine Kars Reveals the Untold Story of the Atlantic Slave Rebellion in the Dutch Caribbean," *UMBC News*, March 22, 2016, http://news.umbc.edu/marjoleine-kars-reveals-the-untold-story -of-the-atlantic-slave-rebellion-in-the-dutch-caribbean.

20. Veerle Poupeye, *Caribbean Art* (New York: Thames & Hudson, 1998); Anne Walmsey, *The Caribbean Artists Movement 1966–1972: A Literary and Cultural History* (London: New Beacon Books, 1992); *Artist and Empire: Facing Britain's Imperial Past*, edited by Allison Smith, David Blayney Brown, and Carol Jacobi (London: Tate Publishing, 2015). Aubrey Williams, 1926–1990, was one of the founders of the Caribbean Arts Movement. His work was also on view at the 2015 *Arts and Empire* exhibit at the Tate Britain museum in London.

21. Gerald Horne, *Confronting Black Jacobins: The U.S., the Haitian Revolution, and the Origins of the Dominican Republic* (New York: Monthly Review Press, 2015)

22. Bush, "10 Hard Labor," *More Than Chattel*.

23. Ibid.

24. Juanita De Barros, "The Garden City of the West Indies," *Order and Place in a Colonial City: Patterns of Struggle and Resistance in Georgetown, British Guiana, 1889–1924*, (Montreal: McGill-Queen's University Press, 2003), 16–48. Of approximately 536,000 contract workers shipped (mostly from India, but also Portugal, China, and West and West Central Africa) to the colonies by the British Empire, 56 percent went to Guyana.

25. Brackette F. Williams, *Stains on My Name, War in My Veins: Guyana and the Politics of Cultural Struggle* (Durham, NC: Duke University Press, 1991), 141.

26. Adam Gopnik, "Kara Walker's Sphinx and the Tradition of Ephemeral Art," *New York Times,* July 11, 2014.

27. See the Brooklyn Museum's website, www.brooklynmuseum.org/ exhibitions/kara_walker_african_boy_attendant_curio_bananas.

5: Booker's Prize

1. Katy Stoddard, "Man Booker Prize: A History of Controversy, Criticism and Literary Greats," *The Guardian*, October 14, 2014. Booker McConnell, Ltd. owned the rights to Ian Fleming's James Bond franchise, as well as 50 percent of the royalty rights of several authors.

2. See the interview with John Berger following the announcement that he had won the Booker Prize at www.youtube.com/watch?v=otu4tjqrOk0.

3. Judy Slinn and Jennifer Tanburn, *The Booker Story* (Petersborough, UK: Jarrold Publishing, 2003); *Guyana News and Information*, "The Booker Story," guyana.org/features/guyanastory/chapter112.html.

4. Ibid., 216.

5. Clem Seecharan, *Sweetening Bitter Sugar: Jock Campbell, the Booker Reformer in British Guiana 1934–1966* (Kingston, Jamaica: Ian Randle Publishers, 2005), 647.

6. Eric Williams, *Capitalism & Slavery* (Chapel Hill: University of North Carolina Press, 1994). Eric Williams was a Trinidadian Howard University professor who would later became the first prime minister of Trinidad. His initial claims that slavery helped finance the industrial revolution in England was dismissed when first published in 1944, but gained widespread acceptance decades later.

7. Cheddi Jagan, "Bitter Sugar," *People's Progressive Party, 1953–1954* (Kitty, Guyana: n.d.), jagan.org/CJ%20Articles/Early%20Aricles/Images/076i.pdf.

8. *Artist and Empire: Facing Britain's Imperial Past*, edited by Allison Smith, David Blayney Brown, and Carol Jacobi (London: Tate Publishing, 2015). The 2015 London *Artist and Empire* exhibit featured three artists from Guyana (Hew Locke, Donald Locke, and Aubrey Williams), more than from any other place in the empire.

9. Walter Rodney, *A History of the Guyanese Working People 1880–1905* (Baltimore: Johns Hopkins University Press, 1981).

10. At the start of the twentieth century, Britain suffered from severe overpopulation and unemployment. The West Indies provided cheap raw materials and a captive market for British products. See Vibert C. Cambridge, *Musical Life in Guyana: History and Politics of Controlling Creativity* (Jackson: University Press of Mississippi, 2015).

11. Stephen G. Rabe, *U.S. Intervention in British Guiana: A Cold War Story* (Chapel Hill: University of North Carolina Press, 2005), 16.

12. Slinn and Tanburn, *The Booker Story*.

13. Seecharan, *Sweetening Bitter Sugar*, 304.

14. Slinn and Tanburn, *The Booker Story*, 16. Richard Booker died in 1838 of malaria at age twenty-four. William died in 1839 of yellow fever at forty-three. A nephew, John Booker, died in 1842 at age twenty-four.

15. S.G. Checkland, *The Gladstones: A Family Biography 1764–1851* (Cambridge: Cambridge University Press, 2008), 186.

16. Sanchez Manning, "Britain's Colonial Shame: Slave-owners Given Huge Payouts After Abolition," *The Independent*, February 23, 2013.

17. Hilary Beckles, *Britain's Black Debt: Reparations for Slavery and Native Genocide* (Kingston, Jamaica: University of the West Indies Press, 2013).

18. Nicholas Draper, *The Price of Emancipation: Slave Ownership, Compensation and British Society at the End of Slavery* (Cambridge: Cambridge University Press, 2010).

19. Matthew Lange, *Lineages of Despotism and Development: British Colonialism and State Power* (Chicago: University of Chicago Press, 2009), 129.

20. Beckles, *Britain's Black Debt*, 149.

21. See the Legacies of British Slave-ownership database maintained by the University College of London, www.ucl.ac.uk/lbs.

22. Slinn and Tanburn, *The Booker Story*, 6.

23. Ibid., 20.

24. Booker has been reorganized several times. In the 1990s, when the International Monetary Fund moved to stabilize Guyana, they required that the sugar consulting firm Booker Tate return to Guyana to help the government-owned Guysuco restructure and become solvent. In 2015, litigation over money Booker Tate said it is owed for these consulting services was still continuing.

25. Slinn and Tanburn, *The Booker Story*, 37.

26. Ibid., 48.

27. Seecharan, *Sweetening Bitter Sugar*, 108.

28. Ibid.; Guyana.org; see also E.B. John, "How Many Indeed Will Recall Booker's Guyana?" letter to the editor, *Kaieteur News*, October 6, 2013.

29. Cheddi Jagan, *The West on Trial: My Fight for Guyana's Freedom* (London: Hansib Caribbean, 1997), 53.

30. Jagan, "Bitter Sugar."

31. Ibid., 17.

32. Jagan, *The West on Trial*; Jagan 2007 (125).

33. A photograph of the October 1961 meeting between Dr. Cheddi Jagan and President John F. Kennedy is available at www.jfklibrary.org/Asset-Viewer /Archives/JFKWHP-KN-C19249.aspx.

34. U.S. State Department archival documents show that $2.08 million was spent on "covert action programs" in Guyana between 1962–1968. See http: //2001-2009.state.gov/r/pa/ho/frus/johnsonlb/xxxii/44659.htm.

35. Stephen G. Rabe, *U.S. Intervention in British Guiana: A Cold War Story* (Chapel Hill: University of North Carolina Press, 2005).

36. Bruce Paddington, "Martin Carter: The Poems Man," *Caribbean Beat*, issue 13, Spring 1995, http://caribbean-beat.com/issue-13/martin-carter-poems -man#ixzz4fn5JXLZF.

37. Janet Jagan, "Glimpses of Martin Carter in His Early Years," *All Are Involved*, ed. Stewart Brown (London: Peepal Tree Press, 1999).

38. Eric Huntley, "No Illusions," *All Are Involved*. Huntley recalls smuggling the poems out of jail.

39. Eusi Kwayana, "The Politics of the Heart," *All Are Involved*.

40. Philip Maughan, "'I think the dead are still with us': John Berger at 88," *New Statesman*, June 11, 2015.

41. Rupert Roopnaraine, "Re-reading Martin Carter," *All Are Involved*.

42. After Dr. Cheddi Jagan finally won the presidency in the first free and fair democratic elections in 1992, he brought back Booker Tate as a consultant to help improve the efficiency of the government-run sugar operations. In 2015, a Guyanese court ordered the government to pay management fees it owed Booker Tate. "Booker Tate Wins $204m Case against GuySuCo," *Stabroek News*, April 1, 2015, www.stabroeknews.com/2015/news/stories/04/01/booker-tate -wins-204m-case-against-guysuco; Sam Jordison, "Looking Back on the Booker," *The Guardian* (January 9, 2008.)

6: Bury the Voice

1. Audio of Rodney's BBC interview with Pascall was available to me, thanks to Dr. Michael McMillan, curator of *No Colour Bar: Black British Art in Action*, which was hosted at the Guildhall Art Gallery in London in 2015.

2. Nishani Frazier, "The Other Jim Jones: Rabbi David Hill, House of Israel, and Black American Religion in the Age of Peoples Temple," *Jonestown Report* 14 (October 2012), jonestown.sdsu.edu/?page_id=34259. The religious sect called the House of Israel was founded by an American exile Rabbi David Hill, also known as Rabbi Edward Washington. It was closely aligned with the ruling People's National Congress (PNC). Its members frequently broke up dissident meetings by force during the period, according to testimony at the Rodney inquiry.

3. According to testimony from Dr. Patricia Rodney at the 2014 Walter Rodney Commission of Inquiry, the scholar had been under surveillance since his student days at the University of London, mostly because of two visits he made to Cuba as a student.

4. Michael O. West, "Walter Rodney and Black Power: Jamaican Intelligence and U.S. Diplomacy," *African Journal of Criminology and Justice Studies* 1, no. 2, November 2005.

5. Rupert Lewis, *Walter Rodney's Intellectual and Political Thought* (Detroit: Wayne State University Press, 1998), 43.

6. Transcript, Honourable House of Representatives, Jamaica, 1968–69.

7. Some reports claim four lives were lost in the Rodney Riots. Michael O. West claimed that six people died. See West, "Walter Rodney and Black Power: Jamaican Intelligence and U.S. Diplomacy."

8. Achal Prabhala, "Guyanarama: In Search of Walter Rodney," *Transition* 13, no. 2, issue 96 (August 2006), 4–35.

9. From 1977 to 1979, there were 383 strikes, including a 135-day sugar worker strike. In 1979, there were 300 strikes; in 1980, 333 strikes. Rupert Roopnaraine, *The Sky's Wild Noise: Selected Essays* (Leeds, UK: Peepal Tree Press, 2012), 88.

10. Report of the Commission of Inquiry Appointed to Enquire and Report on the Circumstances Surrounding the Death of the Late Dr. Walter Rodney on

Thirteenth Day of June, One Thousand Nine Hundred and Eighty at George-town [Guyana], report issued February 8, 2016, http://digitalcommons.auctr.edu/wrcoi/1.

11. "Guyana Government Hands Over Report on Inquiry into Walter Rodney's Death," *Jamaica Observer,* May 11, 2016.

12. Clairmont Chung, *Walter A. Rodney: A Promise of Revolution* (New York: Monthly Review Press, 2012), 124.

13. C.L.R. James, *Walter Rodney and the Question of Power* (London: Race Today, 1983).

14. For more on Rodney's pedagogical approach, see Walter Rodney, *Groundings With My Brothers* (London: Bogle-L'Ouverture Publications, 1969).

15. This is a shortened excerpt from the verbatim hearings. Thanks to Hamilton College professor Nigel Westermaas, an archivist for the Working People's Alliance (WPA), for making these transcripts available to me, and to People's National Congress (PNC) attorney Selwyn Pieters, who posted many of these transcripts on his firm's website.

16. Kate Quinn, ed. *Black Power in the Caribbean* (Gainesville: University Press of Florida, 2014).

17. Carey was a People's National Party (PNP) member from Southeastern Westmoreland.

18. Rodney was invited by conference organizers in the wake of the "fantastic outburst of the peoples of the world" including "guerilla warfare in Africa, Asia and Latin America; upheavals in China and India; and rebellion in North American and Europe." West, "Walter Rodney and Black Power: Jamaican Intelligence and U.S. Diplomacy."

19. Shearer was the third prime minister of Jamaica.

20. Lewis, *Walter Rodney's Intellectual and Political Thought.*

21. Transcript, Honourable House of Representatives, Jamaica, 1968–69, 394.

22. Rupert Lewis, "Jamaican Black Power in the 1960s," *Black Power in the Caribbean*, ed. Kate Quinn (Gainesville: University Press of Florida, 2014).

23. Ibid., 68.

24. Transcript, Honourable House of Representatives, Jamaica, 1968–69, 393.

25. For a fairly hysterical portrait of the Rastas in Jamaica, watch this *60 Minutes* episode from 1980, hosted by Dan Rather: https://www.youtube.com/watch?v=vtgRKZjVA0k.

26. Lewis, "Jamaican Black Power in the 1960s," 57.

27. Rodney, *Groundings With My Brothers.*

28. In the Guyana Embassy files, there are letters from several academics

from Tanzania who agreed that Rodney left Tanzania voluntarily. See http://www.guyana.org/govt/rodney_files.html.

29. Nanjala Nyabola, "Eulogy for Pan Africanism. Long Live Man Africanism," *New Inquiry*, May 23, 2016, thenewinquiry.com/essays/eulogy-for-pan-africanism-long-live-man-africanism.

30. Lewis, "Jamaican Black Power in the 1960s," 54. Shepperson quoted in Lewis's essay.

31. Thank you to E. Ethelbert Miller for pointing out this tradition among black nationalist historians working in the 1970s. As he noted, Chancellor Williams's "Destruction of Black Civilization" famously has no footnotes (although it did have a bibliography).

32. Lewis, *Walter Rodney's Intellectual and Political Thought*, 70.

33. Howard University's E. Ethelbert Miller told me Tanzania's leader Nyerere was tiring of the radical intellectuals stoking freedom movements in the region, and expelled many of them. Personal correspondence with the author, September 2016.

34. V.S. Naipaul, *Middle Passage: The Caribbean Revisited*, reprint edition (New York: Vintage, 2002), 143.

35. Clive Yolande Thomas quoted in Clairmont Chung, *Walter A. Rodney: A Promise of Revolution*, 106. "Margaret Thatcher liked Burnham as a person. Because he would do things others wouldn't do. He'd go up and almost like flirt with her, make nice facetious comments about how attractive she looked. Burnham knew how to play the game, so he was never isolated by the international community because of what was happening at home. It was said that Burnham literally flirted with Queen Elizabeth at the time that he was handed the reins of power during Guyana's Independence in 1966."

36. Dr. Patricia Rodney's 2014 testimony to the Walter Rodney Commission of Inquiry supplied many of these details about the climate in which her husband lived in his last days.

37. Walter Rodney, *The Struggle Goes On: A Speech by Walter Rodney* (Georgetown, Guyana: Working Peoples' Alliance, 1984). This speech took place on July 20, 1979, according to Walter Rodney Commission of Inquiry testimony from Eusi Kwayana.

38. "Bernard Darke SJ," *Jesuits in Britain*, www.jesuit.org.uk/node/1246.

39. Rodney, *The Struggle Goes On*.

40. The Jonestown massacre was the origin of the phrase "drinking the Kool-Aid," as followers were urged (and in some cases forced) to drink the sweet drink laced with cyanide.

41. Alfred, Lord Tennyson, "Crossing the Bar," Poetry Foundation, https://www.poetryfoundation.org/poems-and-poets/poems/detail/45321.

42. See testimony from Donald Rodney, Patricia Rodney, and Karen DeSou-

za at the Walter Rodney Commission of Inquiry, http://digitalcommons.auctr .edu/wrcoi.

43. See Nigel Westmaas's testimony at the Walter Rodney Commission of Inquiry, http://digitalcommons.auctr.edu/wrcoi.

44. See Donald Rodney's testimony at the Walter Rodney Commission of Inquiry, http://digitalcommons.auctr.edu/wrcoi.

45. According to U.S. State Department documents publicized by Wikileaks, the State Department was monitoring the situation and noted Rodney's snub of Burnham.

46. See October 22, 2014, testimony of Patricia Rodney during the Walter Rodney Commission of Inquiry.

47. John Gimlette, *Wild Coast: Travels on South America's Untamed Edge* (New York: Vintage Books, 2012), 45–47. I also interviewed Gimlette in July 2016 by phone, and he reviewed the notes that he had written in 2009 after his interview with Roopnaraine.

7: Lotus

1. Selwyn Collins, "Conversations with Selwyn," https://www.youtube.com /watch?v=DQZn82wjEug.

2. According to CIA statistics, more than 55 percent of people born in Guyana live abroad. *World Factbook 2013–14*, Washington, DC: Central Intelligence Agency, 2013, http://www.cia.gov/library/publications/the-world-factbook/index .html.

3. Chisholm, who represented Brooklyn in the U.S. House of Representatives and became the first black woman candidate to vie for a major party's nomination, has Caribbean roots: her father was from British Guiana (and her mother was from Barbados).

4. "Aishalton Teacher Faces Expulsion from Village," *Capitol News Online*, January 6, 2015; "President's Guard Slaps Aishalton Teacher for Criticizing Ramotar," *News Source Guyana*, December 4, 2014.

5. "Torture Cops' Promotion Will Blemish Guyana—Granger," *Kaieteur News*, February 14, 2015.

6. Kati Cornell Smith, "'Goodfella' Attorney Gets 14 Yrs.," *New York Post*, December 5, 2009.

7. "Shaheed 'Roger' Khan: Drugs, Dirty Money and the Death Squad," *Stabroek News*, August 20, 2009.

8. Gaiutra Bahadur, "CIA Meddling, Race Riots, and a Phantom Death Squad: Why a Tiny South American Country Can't Escape the Ugly Legacies of Its Idiosyncratic Past," *Foreign Policy Magazine*, July 31, 2015.

9. Ruel Johnson, "Bernadette Persaud: 'I'm Trying to Show That Here Is

Beauty,'" *Caribbean Beat*, issue 68 (July/August 2004), http://caribbean-beat
.com/issue-68/bernadette-persaud-im-trying-show-here-beauty.

10. "Crum-Ewing Was More a Nuisance Than a Threat—President Ramotar," *Kaieteur News*, March 25, 2015.

11. The columnist Freddie Kissoon was a major critic of the ruling PPP party.

12. Mark Benschop was a television host who covered a People's Progressive Party protest that turned violent and was jailed for five years. See "Mark Benschop from City Hall to Prison to Pardon," *New York Daily News*, August 30, 2007.

Index

About the Author

A former staff writer, editor, and culture critic at the *Washington Post* and *The Root*, **Natalie Hopkinson** is an assistant professor in Howard University's graduate program in communication, culture, and media studies and a fellow at the Interactivity Foundation. The author of two critically acclaimed books, *Go-Go Live* and *Deconstructing Tyrone* (with Natalie Y. Moore), Hopkinson lives in Washington, D.C.

Celebrating 25 Years of Independent Publishing

Thank you for reading this book published by The New Press. The New Press is a nonprofit, public interest publisher celebrating its twenty-fifth anniversary in 2017. New Press books and authors play a crucial role in sparking conversations about the key political and social issues of our day.

We hope you enjoyed this book and that you will stay in touch with The New Press. Here are a few ways to stay up-to-date with our books, events, and the issues we cover:

- Sign up at www.thenewpress.com/subscribe to receive updates on New Press authors and issues and to be notified about local events
- Like us on Facebook: www.facebook.com/newpressbooks
- Follow us on Twitter: www.twitter.com/thenewpress

Please consider buying New Press books for yourself; for friends and family; or to donate to schools, libraries, community centers, prison libraries, and other organizations involved with the issues our authors write about.

The New Press is a 501(c)(3) nonprofit organization. You can also support our work with a tax-deductible gift by visiting www.thenewpress.com/donate.